敬祈 幸澎 祥 董事長 指正

慶 ... 永 2020.9.7
敬贈

詹阿水創作精選

形與色的探索

The Selected Arkworks
by Chan A-Shui

**The Exploration of
Shapes and Colors**

在工作室作畫中的詹阿水

2015 年

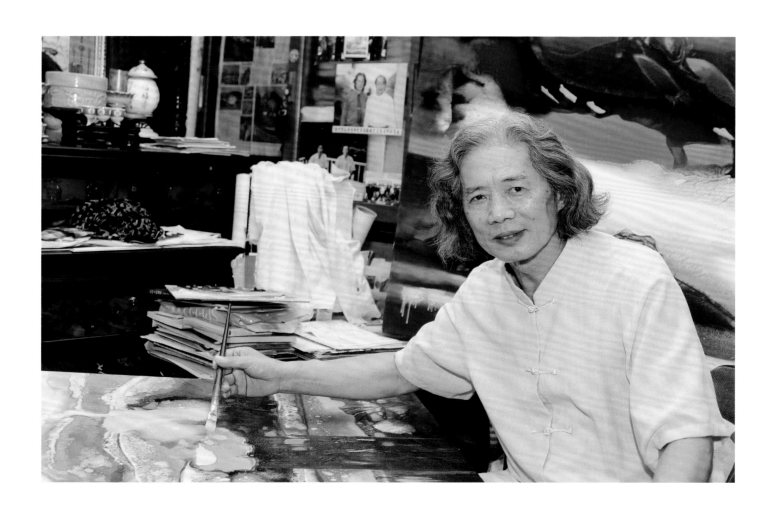

文｜詹阿水

卓蘭詹氏二公子、家中清寒子自立

　　詹阿水，1946 年（民國 35 年）出生於苗栗縣卓蘭鎮鄉下的山城。我的家鄉卓蘭鎮是個山明水秀、風光宜人的水菓之鄉，家裡共有四兄弟三姊妹，在家中排行第四。由於父母親務農，家境較清寒，撫養 7 個孩子的日子是非常辛苦的。

　　記得小時候住在鄉下舊式的土角厝，每逢下雨時，就見到父母親忙著拿著水桶、臉盆接屋內漏水。當時電力不普及，照明以點燃煤油燈為主，房間的床是用一塊塊長型木板拼成，鋪上一些稻草、一張草蓆，雖然半夜翻身會聽到木板吱吱的作响，但這就是我們每晚安眠無憂的床舖。兒時成天都是光著腳走路，晚上上床前洗好澡就穿上父親親手做的木屐，印象中就讀至國小時都沒有穿鞋，於國小六年級畢業旅行時才買第一雙布鞋，當時興奮之情，無法言喻。內衣是母親用麵粉袋縫製而成，衣服就是姊妹兄弟相傳，破了補後再穿。

　　父親於農忙之餘就到大雪山林場筏木或幫人建土角厝、草茅屋（家畜農舍），賺錢貼補家用，有時一去就是兩、三個月，故田裡的農務、家中的菜園、農舍的家畜、家中照顧孩子的工作，全落在母親的身上。見父母親為了養育七個孩子，白天在外工作，省吃儉用，做孩子的我們也不敢有怨言，兄姊會主動地看顧弟妹，也因此家中的孩子從小就有很高的自主性，負起了開灶起爐、煮飯燒水等日常工作。兒時的種種昔景，如今仍記憶猶新，於現今 21 世紀的生活相比，有如天壤之別。

幼時承受父啟蒙、書畫琴築皆略獵

家裡住的土角厝，是父親親手建造的。隔間是用竹子編織而成，牆壁是由兩三寸長短的稻草加上泥土混泥漿而沏成的，牆壁表面乾了再塗上石灰粉，牆壁表面脫落了，就用肥料紙袋或水泥紙袋剪開彌補。從小看見父親用水泥紙袋做為繪製土角厝或草屋的建築藍圖，我也在旁邊學著畫製，這可能就是父親啟蒙我從小喜歡繪畫的種子。兒時最快樂的時光就是畫畫，有時以同學看過且不要的漫畫書為素材，或是一些雜誌、報紙的插畫臨摹練習。記得當時我以家裡的牆壁來做塗畫練習，父親不但沒有責備，還親手撿了許多水泥紙袋，剪成半張報紙大小，串成冊給我作畫，當時父親的用意雖沒有要我以後當畫家，但卻無意中鼓勵我朝繪畫之路前進。

記憶中的父親除了克苦耐勞，事必躬親之外，亦是多才多藝。除了專長房屋建築，還親手製作一些務農的農具，閒暇之餘，對音樂有興趣的父親會拉胡琴、鋸琴，參加子弟班唱鄉土民謠。父親於學堂讀過半年的漢書，且練得一手好書法，每逢過年鄰居都會向父親索取春聯，如有剩餘的還會到街上擺攤位賣春聯。由於在父親的薰陶下，我對書法、音樂、建築等皆多有涉取。

少時習築奠基礎、父親早逝棄從工

在農業社會的時代，農家子女以家中農務為主，很少有升學的機會，因而兩位姊姊國小畢業後就沒再升學，大哥也只讀至國中畢業就到彰化學藝，農事亦少外雇工人，都是家中成員總動員，因此在高中時我就已經學會翻土、插秧、施肥、割稻。

由於家境所使，我讀國小時的志願，就是要做一個建築師，建造一間新的房子給家人住。如此的志願亦使我於初中、高中時，選擇職業學校的建築科系就讀，也因而在學校奠定了素描，以及空間繪畫的基礎。

在校園曾是風雲人物的我，是排球、籃球的校隊隊員，也參加了樂隊。於寒暑假時，我約同學組成割稻班，幫人割稻賺取學費，高中時的學費就靠自己半工半讀下完成。

記得高一的一堂化學課，我於上課時拿起畫紙素描化學老師長髮飄逸、氣質出眾的人像，下課時無法交出作業，老師用驚訝的眼神看著那幅素描，心想會被教訓或記過處罰，結果出乎

意料之外，化學老師請來學校的美術老師，說班上有位同學有繪畫才藝，獎勵了一番，把素描像掛在老師的辦公室。至此之後，學校要我多畫些作品，再經美術老師的指導，經常代表學校參加台中縣舉辦的美術比賽，得了幾個獎項回來，替學校爭光。學校也贈送畫紙、水彩顏料、畫筆做為獎勵。處於當時家家務農的年代，在農村裡能有繪畫的機會，若沒有老師們的建議及支持，是何等的不容易，也因為他們的鼓勵，使我對繪畫的熱誠不減。

繪建築完工的成品圖，也是我在學校的專長。學校建築科系的楊文德老師，暑假帶著學生到台北中山北路剛開始建的國賓飯店工地實習監工，讓我吸取建築的實際經驗、受益良多，更進一步對空間的繪畫有更深一步的瞭解。

在十九歲高中畢業那年，我當隊長帶領 150 多位的同學，參加救國團舉辦的暑期活動－橫貫公路途步旅行，由南投縣埔里徒步行走到花蓮，日行 30~40 公里，第一次到橫貫公路處處驚喜，沿途被壯麗的風光，深深的吸引，對巧斧神功的景觀，嘆為奇景，回程由花蓮乘軍車行駛蘇花公路回台北，又是一次的驚喜，當時狹窄的公路，一邊是峭壁、另一邊是斷崖與太平洋，景觀也相當迷人，沿途拿起鉛筆素描、照相，做為繪畫的素材。蘇花的美景於我日後對繪畫風景的熱愛上，有很深的影響。

懷著念念不忘蘇花的情懷回到家裡，晚上與家人分享見聞，敘說著旅程中的種種樂趣，全家人都融合在快樂的氣份中。那知天有不測風雲，於就寢之時，聽聞母親驚叫，父親中風，倒在床上，臉上發白，口吐白沫，馬上請診所的醫生來醫治，醫生說明父親的病情很不樂觀，如果醫好也可能變成植物人。因家中經濟狀況欠佳，經與長輩們商量，決定再請當地的醫生醫治，沒有送到都市的大醫院。竟想不到，一天之內父親就往生了。這是我人生中最低落的一年，家裡失去了主要的經濟支柱來源，重擔全落在母親身上。本來在學校的成績還不錯，可保讀就學，但自從父親往生後，體念母親擔子太重太辛苦了，改變了想法，高中畢業後，想分擔家計，放棄了升學，決定北上到建設公司上班。

工閒之餘不忘畫、勤於創作傳海外

北上後在工作閒暇之時，奈不住對繪畫的喜愛，就到美術館、博物館、畫廊看畫展，當時最吸引我的繪畫大師有藍蔭鼎、黃君壁、張大千、楊三郎、陳澄波、劉獅、歐豪年等，他們的

畫冊是我臨摹的範本。我知道" 萬丈高樓平地起 "，為了使自己素描基礎更為精進，則需熟能生巧，平時除了繼續到郊外及風景區作風景寫生之外，亦撥空到台北火車站候車室以及西門町獅子林廣場，依椅而坐，素描車站內的眾生百態、等車之人的臉部表情及身體姿態、來往之人群及周遭的街景，以加強素描功力。這段期間的磨練，使我對於線條粗細、明暗對比、距離比例等獲得紮實的基礎。

在建設公司上班期間是我人生中的一個轉淚點。當時建設公司推出一批別墅銷售，蓋了華麗美觀的樣品屋，老闆要我繪畫一些風景水彩畫掛在顯眼之處。當時有位客戶來看預售屋，參觀了樣品屋之後成交買屋，並要求交屋後，要掛我的畫。經由老闆介紹後才知悉這位客戶是貿易公司的董事長，是位日本華僑，在日本有五家藝品店，他請我於工作之餘畫 20 張水彩畫，帶到日本的藝品店銷售，不到半個月左右，作品已經銷售一空。此消息令我既興奮欣慰自己的作品有人欣賞，又感激董事長的支持與認可。之後持續約一年時間才放棄了本身所學的建築，全心投入繪畫的創作工作，很感激當時建設公司老闆的支持，他說，如果我在藝術路上走不下去，就再回來建設公司上班，給了我有退路的後盾，真的我就一路走下去沒有回頭。

佈景書畫廣學精 、色材應用更得心

於入伍後，因學有專長，在訓練中心參加排球隊又畫壁報，加上少時於初中、高中參加過樂隊，不到半個月，就被陸軍總部征召到軍樂隊參加總統府雙十國慶遊行，而後又被征調到陸軍藝工大隊。當時的藝工隊，每年都在台北市中華路的國軍文藝活動中心舉辦金像獎競賽、表演歌劇。有一次，劇中需要四到五個佈景，當時隊上邀請到日本電視台製作佈景的專家，製作佈景需要助手，隊長就請我幫忙，雖然當時在當兵，但有不少繪畫的機會，向日本製作佈景專家學了製作佈景的技術。

在陸軍藝工大隊服役時，隊上的輔導長姚浩先生是位國畫家，也是書法家，很幸運的授其指導，使我於國畫及書法的技術，更上一層樓。在我退伍時，當時陸軍藝工大隊隊長介紹我去國防部藝工總隊兼差，平時除排練之外，一個月約有十場左右的演出。有閒餘時間以及自立門戶之後也接幾個大型節目的佈景製作，如木柵動物園恐龍館背後的景觀，大衛魔術、金馬獎、金鐘獎的佈景，還有龍兄虎弟、一道彩虹、世界真奇妙等電視節目的佈景，朱銘美術館大型壁

畫，有時亦幫人做廣告美術及室內的設計。從入伍至退伍，我在繪畫的領域上接觸更廣，亦讓我在材料的應用上更能得心應手，顏色的運用上更佳膽大而心細。

壯時投創遭反對、奮力以畫立家業

當我毅然決然全心全意投入油畫的藝術創作工作時，週遭的親朋好友們均持反對的立場，並且不時的告之，如國內外電影、電視、小說般的情節所述，當畫家的都是窮途潦倒。甚至要結婚時，太太的娘家也是再三的反對而有所顧忌。早期有作品時就拿到畫廊寄賣托售，例如黃歌川畫家所開的畫廊、學校美術社、南山畫廊、聯合畫廊、好來藝術中心、僑聯畫廊等等。為了能創作更多的作品，我回到北橫、中橫、南橫三條橫貫公路寫生，一見大自然巧妙美景，即思緒泉湧，且每回皆有不同的感動，當時共花了二十餘天，完成了二十五幅作品，在台中大雅路的畫廊展覽，幾乎八成作品都被收藏。當有人收藏或欣賞時，則更加加深我走畫家這條路的信念。

皇天不負苦心人，經過不斷的努力終於有現在的成就，我也靠繪畫扶養三個子女，如今也均成家立業，事業有成，此為我一生中最欣慰之事。在此要感謝家人，尤其是太太的鼓勵與支持，使我無後顧之憂，全心全力的去創作，還有陳火木老師給我畫人像的指導，陳顯棟老師給我繪畫上的指導，當然也承蒙許多藝術界的前輩與各界專業人士的鼎力相助，以及收藏家們的支持與鼓勵。

在繪畫的歲月裏，弟弟詹金水從國中畢業後就隨我上台北習畫，他自已也很努力地在我這裡半工半讀完成高中、大學的學業，直到結婚成家才離開，兄弟分開各自努力，如今在繪壇上有一習之地，也是我值得欣慰的地方。

如今佳作廣流傳、寫意抽象憾人心

如今我的作品圖像承蒙大專院校教師垂愛採用，做為教學教材，如國立台灣大學、國立師範大學、逢甲大學、國立東華大學、彰化師範大學、國防大學、香港理工大學、香港城市大學、澳門大學、中國美術學院、南京藝術學院、湖北美術學院等六十餘所國內、國外藝術系的學校。身為一位藝術繪畫工作者，作品能給更多人欣賞，實為對我的正面肯定。

早期的作品水彩畫以寫生風景、靜物及動物為主，國畫就以工筆風景山水、竹子、蘭花、盆景、水果為主，油畫作品以風景、寫實、古典、人像為主，後期至今的作品多以油畫抽象為主。為表達澎湃的創作意念，描繪內心的世界，在作品中增加了許多夢幻的境界以及想像的空間，以趣味自然的肌理來表現大自然的美，令觀賞者在心動驚豔之餘，情不自禁要停駐畫前，細細品味畫中的神秘境界，心感震憾悸動之餘，仍能欣賞大自然協調的色調之美。當我陶醉在創作的領域時，即能完成一幅令自己滿意的作品，一定要自己看了喜歡而感動，觀賞者才會喜歡而受感動，進而融入我作品的境界中，那種欣慰的心境，是我人生中的最高享受。

從繪至今五十載、戰戰兢兢勤不斷

從事繪畫藝術工作近五十年，個展、聯展約五十餘次，對於藝術領域，自我始終抱持著不斷研究且創新的心態，從生活中、大自然中取靈感，希望能在繪畫的領域創造出新穎的風格，特殊的風貌。雖然我並無接受傳統學院派的教育訓練，在藝術繪畫的路上，也比許多的畫家要走得更加辛苦，但我秉持著三人同行必有我師的心態，碰到畫家前輩就向他請教。我認為人生本身是個最佳的老師，如前所述，我一生走來，所碰到的人、事、物，是支持與鼓勵我創作的動力，對於當初選擇繪畫工作，我始終無怨無悔，一路走來也很幸運的碰到許多貴人。我堅信藝術繪畫是我要走的路，且會更加勤奮努力來充實自己的畫藝。

感謝國內外各界對我的厚愛及肯定，及藝術界同好前輩們的指教，期盼自己能更上一層樓努力創作出更具生命力的作品，來答謝各界對我的關愛與支持。

Biography of Chan A-Shui

By Chan A-Shui

2nd son in the family. Learnt to be independent under straitened circumstances

Chan A-Shui was born in 1946 in the Zhuolan Township in Miaoli County, known as the region of fruits with a picturesque scenery. There were 4 brothers and 3 sisters in my family and I was the 4th child. Because my parents made a living by working in paddy fields, it was difficult for them to raise 7 children in straitened circumstances.

The walls of our old family house were made from the mix of soil and straws and the thatched roof could have leaked whenever it rained. I remember seeing buckets inside on the floor for collecting dripping water on rainy days. There was no electricity and kerosene lamps were used for lighting. Long wooden planks were put together as mattresses in the bedrooms, straw mats were used to cover the planks. Although the planks creaked when I turned around in the middle of the night, these were good beds which provided us warmth every night.

I walked in my bear feet most of the time when I was a child and only wore a pair of Japanese geta handmade by my father after taking a bath and before going to bed in the evening. As far as I

remember, I wore no shoes even when I went to primary school. The first pair of shoes that I wore were sneakers bought for my graduation outing when I finished the sixth grade of primary school. My mother made underwear by sewing flour sacks together for her children. The clothes I wore were repaired many times and basically the elder siblings passed on clothes to the younger ones.

When my father was not busy with works in the paddy field, he went logging in the forest of the Snow Mountain. He also built houses or farm houses to earn extra money to support the living cost of the family. Sometimes, he had to go for 2 to 3 months to perform those works and then my mother had all the work loads including working in the paddy fields, taking care of the vegetable garden, feeding the livestock and looking after the children. In order to raise 7 children my parents worked hard and lived frugally. Being part of the family, the children did not dare to complain. On the contrary, the elders would spontaneously look after the younger ones. Therefore, the children of my family had a high level of autonomy and were responsible for cooking and daily errands.

All the memories of my childhood are still fresh in my mind, what a huge difference compared to the current life style in the 21st century.

Enlightened by my father as a kid. Got involved in calligraphy, music and architecture under my father's influences

The old family house was built by my father with his two hands. Woven bamboo covered with 2 to 3 inches of straw mixed with soil was used for building partitions in the house. After the soil was dry, my father coated the walls with layers of lime plaster. If the surface of the walls came off over time, he repaired it by applying pieces of paper from cement or fertilizer bags. My father drew blueprints of the house or the farm house that he was about to build on cement bags. Maybe, because I often watched him while he sketched, I developed a liking for drawing. The happiest moment of my childhood was when holding a pencil sketching here and there. I practiced a lot by copying the figures in the comic books which were thrown away by my classmates or the objects I could find in the illustrations of

magazines or newspapers. Sometimes I drew on the walls of the house, my father did not blame me, instead, he collected many cement bags, cut them into the size of half a newspaper and bound them into drawing books for me to practice. I believe that my father did not try to guide me to be an artist but unintentionally encouraged me to continue on the path of painting.

My father in my memory, not only worked hard and took care of everything personally, but also had multiple talents. His expertise was in building houses and in hand making some farming tools used in the field. In his free time, he played Huqin (a two-stringed bowed instrument), musical saw (the application of a hand saw as a musical instrument) and participated in local folk song classes. My father learnt hanzi for a half year in an old type of school and turned out to be a good calligrapher. During the Chinese New Year, neighbors would ask my father to write new year scrolls for them. My father would make some and sell a few in the market if there were too many. Under my father's influence, I got involved in calligraphy, music and architecture.

Studied architecture in school and formed the foundation for depicting and space. Gave up higher education and went to work because of my father's sudden death

In the agricultural society, most of the children from farming families had to work in paddy fields and had less opportunities to study. Therefore two of my elder sisters only completed primary school education and my elder brother went to learn fruit farming in ChungHua County after graduating from junior high school. We could not afford to hire outside workers, instead, all the family members had to share work in the paddy fields. I was capable of plowing, planting, fertilizing and cutting rice when I was a senior high school student.

Because of the difficult situation we were in, my wish in primary school was to be an architect and to build a comfortable house for my family. Later on, the wish of my youth made me choose the major of architecture in occupational school. The study of architecture helped me to form the foundation for

depicting and space concept.

I was once "the man of the moment" on campus, selected for the volleyball and basketball school teams and a member of the school band. In order to earn some money for each semester's tuition fees, I would team up with my classmates to work for farmers in the paddy fields during the winter and summer vacations. By working part time, I could finish my high school education without asking money to the family.

I remember that the chemistry teacher of my class in the 1st year of high school had beautiful long hair and an elegant appearance. One day, I could not pay attention to the black board and could not help but draw her portrait on a piece of paper while other classmates were busy doing their assignments. When the class was over, I did not hand out the assignment, the teacher looked at the portrait with surprise. I waited for the punishment to come, but on the contrary, the teacher introduced me to the art teacher, praised my talent in art and hung the portrait in her office. From that time, under the art teacher's guidance, I was encouraged to draw and represented my school to participate in the painting competitions in Taichung County. I won a few awards and brought glory to the school. The school gave me drawing papers, watercolor paints and brushes as a reward. In those years, to be able to have the opportunity to draw in an environment where parents wanted their children to work in the paddy fields could not have been easy without the support and advice from teachers. Thanks to their encouragements, I could develop my passion for painting.

Architectural drawing is one of the qualifications that I acquired in school. One summer, professor Yang Wen-De of the architectural department in the school took students to observe the construction site of the Ambassador Hotel at Zhongshan North Road in Taipei. Because of that field trip, I gained a lot of practical experience in construction and had further understanding of space.

When I was nineteen years old, after high school graduation, I participated in a summer activity held by the China Youth Corps (CYC). I was appointed as the leader of the team and led more than 150 classmates trekking 30-40 km daily on the cross-island highway from Puli Nantou County to Hualien.

On the way back, military cars drove us on the Suhha highway from Hualien to Taipei. The road was narrow, one side consisted of precipitous rocks and the other side was a cliff overlooking the Pacific Ocean. The magnificent scenery during the whole journey fascinated me. I either sketched with pencils or took photographs of the scenery as painting materials. The beautiful SuHua area had a great influence for my passion for landscape drawings.

I came home with unforgettable memories of SuHua area and shared what I saw and the interesting journey with my family members. The whole family was in a happy mood and without any signs of warning we heard mother's screams before going to bed. My father had had a stroke and laid in bed with a pale face and foam coming out of his mouth. We immediately asked a doctor from a clinic to see him but he was pessimistic about his condition and explained the possibility for my father to stay in a vegetative state. Due to unfavorable economic conditions at home and after consulting with senior relatives, my mother decided to send my father to the local clinic and not to the major hospital in the city. Unexpectedly, my father passed away within one day. That year was the bottom of my life, we lost our father who was the bread earner in the family and our mother had to carry all the loads. Because of my good grades in senior high school, I could have continued to study in college without passing an exam but after my father's death and considering that my mother had to carry heavy burdens, I wanted to share the living cost of the family. So I changed my mind, gave up studying further and decided to work in a construction company in Taipei.

Built up solid base in sketching skills in my spare time after work. My artworks were sold in Japan which was the turning point in my life

In my spare time after work, I could not stop my liking towards painting. I often went to see exhibitions at museums of art and art galleries. At that time, I was highly attracted to paintings done by masters like Lan Yin-Ding, Huang Jun-Bi, Chang Dai-Chien, Yang San-Lang, Chen Cheng-Po, Liu Shih, Ou Hao-Nien. Their painting albums were the materials that I used for imitation. A Chinese proverb says that "all high rises start from the ground", in order to have a solid foundation in drawing skills, I had to draw a lot. I went to the countryside or to scenic places for practicing landscape painting. I went

to the waiting room of the Taipei Station and the Lion Square of Xin Men Ding District, took people who were waiting for their transportation as my models, sketched streetscapes and crowds to practice portrait sketching or figure and gesture drawing. During that period of training, I built up a solid base in sketching skills, line thickness, contrast and space.

Working in a construction company was the turning point in my life. The company constructed some villas and built model houses for customers. The boss asked me to paint some watercolor landscapes and hung them on the walls behind the reception and the walls of the living rooms, bedrooms and dining rooms of the model houses. A customer came to see a model house and bought one villa with the agreement from the boss to hang my paintings in every one of his rooms. After the boss introduced him to me, I contacted this Japanese Chinese customer who was also chairman of a trading company. He wanted me to make 20 watercolor paintings and sell them in his 5 painting shops in Japan. Less than 15 days after he returned to Japan, he told me that all the paintings had been sold and he asked me to continue to provide him with more paintings. I was happy and excited to learn that there were people appreciating my artworks and grateful to have the support and recognition from the chairman. After working in the construction company for 1 year, I decided to devote myself full time to painting. The boss of the construction company was nice to support my decision and kind enough to tell me that he would be happy to have me back anytime, if the path for being an artist was too difficult. Knowing that the boss was there to support me, I took that path and never returned to his company.

Learnt the skills of stage scenery making and improved ink painting and calligraphy. Enhanced my ability to utilize materials more proficiently and to apply colors more boldly

Less than half month after I was conscripted in the army and due to my expertise in architecture and experience in student bands, I made posters in the soldier training center and was called to join the marching band by the army headquarter to perform for the Double Tenth National Day parade at the Presidential Palace. I also participated in the volleyball team. Afterwards, I was transferred to the Military Artistic Service Group in the Army which held Award contests and opera performances

annually at the Chinese Armed Forces Cultural Activity Center in ZhongHua Road in Taipei. Four to five stage sets were needed for a play and the Military Artistic Service Group invited artists from Nippon TV who specialized in this field to do the job. I was able to assist, got some opportunities to paint and at the same time learnt the skills of making stage scenery from experts.

The chief counselor of the team, Mr. Yao Hao, was an ink painting artist and also a calligrapher. I was lucky to have him guide me and help me to improve my skills in ink painting and calligraphy. After being discharged from the military, the Chief of the Military Artistic Service Group of the Army introduced me to a part time job to play clarinet, saxo alto and saxophone in the band of the Military Artistic Service Group of the National Defense. Except for rehearsals, I participated in around 10 performances a month. In my free time after I started my own painting studio, I painted stage sceneries for the Dinosaur Hall of the Taipei Zoo, Magician David, the Golden Horse Film Festival, the Golden Bell Awards and for TV programs such as "Dragon and Tiger Brothers", "The Rainbow", "The World is Wonderful". I also did large size wall painting in the Juming Museum. Sometimes, I did typography work for advertisements and designed interiors. During those years, I was exposed to different areas related to painting which enhanced my ability to utilize materials more proficiently and to apply colors more boldly.

My determination to be an artist suffered from strong opposition in the beginning. Through years of endeavor, I have achieved my artistic goals and established a family

When I resolutely determined to devote myself to oil painting, friends and relatives took opposite views and from time to time warmed me that the artists described in films, TV and novels all ended up with impoverishment and desperation. Even when I was about to get married, the family members of my wife were concerned and reluctant to agree with our marriage. At that time, my paintings started to be consigned by Huang Kao-Chuang's Gallery, the art association of schools, the Nan-Shan Art Gallery, the United Art Gallery, the Hao-Lai Art Center, the Qiaolian Art Gallery, etc. To create more paintings and to get inspired from the nature I went back to the Northern, Central and Southern cross-

island highways. My heart was moved and my mind was filled with thoughts every time I went to those places. I finished 25 paintings within around 20 days, they were exhibited and 80% were sold at the gallery on Daya Road in Taichung. When paintings were sold, it would only deepen my belief in the path I took.

"God helps those who help themselves", with years of endeavor, I finally have some achievements in my career and I also created a family with my wife. Our 3 children have their own families and their careers which is of great comfort to me. I would like to thank my family and especially my wife for their continuous encouragements and support, so that I can focus on creating artworks without worries. In addition, I am thankful for the guidance of Master Chen Huo-Mu for portraits and of Master Chen Hsien-Tung for paintings. Finally, I am grateful for the great help that I received from seniors in the art society and professionals in various industries and for the support and encouragements from the art collectors.

My brother, Chan Chin-Shui, came to Taipei to stay with me and learnt painting in my workshop after he graduated from junior high school. He worked and studied hard to finish his higher education in college and only left me when he got married. After years of hard work, I am happy that he achieved great fame in the art society.

Nowadays, there are more people appreciating my artworks and the abstract style moves people's hearts

Nowadays, the images and prints of my artworks are utilized as teaching materials by art teachers in more than 60 Taiwanese and non-Taiwanese universities and colleges, such as National Taiwan University, National Taiwan Normal University, Feng Chia University, National Dong Hwa University, National Changhua University of Education, National Defense University, Polytechnic University, City University of Hong Kong, University of Macau, China Academy of Art, Nanjing University of the Arts, Hubei Institute of Fine Arts. It is a great honor to be recognized and a great happiness to know that

there are more people appreciating my artworks.

In the early stages of my career, I focused on scenery, still life and animals for watercolor paintings; I elaborated landscapes, bamboos, orchids, bonsai and fruits for ink paintings; I used brushes and painter's knives for landscapes, figurative works, classic realism and portraits for oil paintings. Later and until now, I mostly do abstract oil paintings. In order to express my out-flowing ideas and depict my inner feelings, I add many fantasies to my artworks to give viewers space for imagination. I apply interesting textures on the canvas to present the nature's beauty and to let viewers sink in the realm that I create. When people are moved, they can't keep their eyes off it. Then, they want to spend more time to explore my mysterious world and to appreciate the harmonized colors representing the nature's beauty in the paintings.

When I immerse myself in art creation, I can finish a painting which makes me feel satisfied. I am moved by my own creation, then viewers will follow and understand the realm that I want to express. When this can be achieved, I find it a great accomplishment and a joy in life.

50 years of experience in painting, never stop making improvement

Almost 50 years of experience in painting, participated in around 50 solo and joint exhibitions. My attitude towards art is a constant search and innovation. Sourcing inspiration from daily life and the great nature, I hope to create my own style. I did not have a traditional training from college, my path of being an artist was tougher than others. But I am in a state of mind for learning whenever I can from my seniors, it's just like a saying in the Confucian Analects: " When I walk along with two others, they may serve me as my teachers". I believe that "life itself" is the best teacher, as stated above, the people whom I have encountered, the events that have happened to me, and what I have seen in my life, these are the drivers for being a creative artist. I never regretted choosing art as a career. I was lucky to have met many people helping me all the way. I believe that I am on the right path and will endeavor to improve my artistry.

I would like to send my gratitude to people and friends in Taiwan and aboard for their support, recognition and appreciation. I also would like to thank the seniors and the art lover who gave me advice. In conclusion, I hope that I can continuously improve and create more powerful and lively masterpieces in order to thank everybody for all the love and support that I receive.

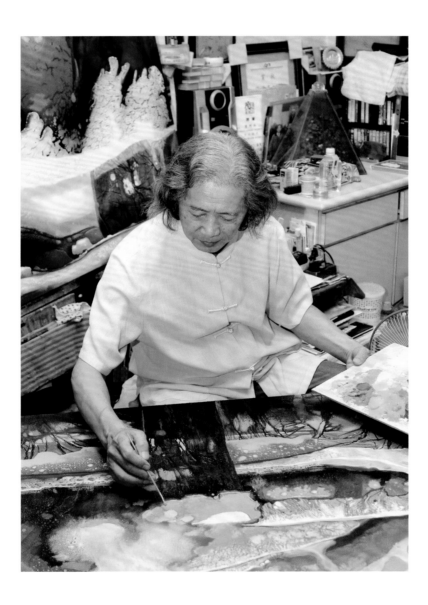

現代藝術創作的理念與思維

文｜詹阿水

　　藝術創作是奧妙的，具有神秘的吸引力與無形的魔力。繪畫創作正有如創作世界名曲一般，譜曲雖只用七個音符，但加上高低音、輕重音、快慢節拍，此所組成的弦律，就能奏出動聽迷人的音樂，憾動人們的心靈，聆聽百遍而不厭。繪畫藝術也有異曲同工之妙，紅、橙、黃、綠、藍、靛、紫，七個主題顏色，經過調合美化，能繪畫出千變萬化的作品。好聽的樂曲，音符中傳達著深沉、寧靜、渾厚的內在美，撫慰人們的心靈，把這些元素加在繪畫創作中，具有生命力、感染力的作品自然就會憾動觀賞者的心靈，令其愛不釋手。

　　為了探索藝術創作其中的奧秘，為了長遠地走藝術這條路，持有樂觀進取的態度以及接觸靈感涉取的來源是很重要的。在創作藝術的過程中，外出旅遊能增廣見聞進而產生靈感。「靜觀萬物皆自得」，大自然的造物為世上最美之景，加上氣候時節變遷，景色千變而萬化，故遊走大自然，靜觀萬物奇色，取材大自然萬物，記錄其提示之意境，讓思維沉澱、心思放空，創作的靈感則泉涌而出，再用畫筆與色彩在作品中發洩，擺脫前人的規矩模式，則能創造出自有的風格與美感。

　　繪畫藝術亦具有修身養性的功用。繪畫為靜態活動，創作需要堅持與毅力，揮筆作畫時則需集中凝神，當畫到忘我的境界，則有欲罷不能之舉。因而繪畫可助人進入忘憂的美妙意境，有益於精神與心靈的豐實。繪出一幅滿意的創作，莫不是人生的一種成就感及樂趣，當「樂在其中」、「此生不虛此行」之感湧然而升，畫藝自然就會提昇，自然在無形中豐富內在的生命。

週遭親友皆為影響我的正面因子，鼓勵我習畫而近藝術豐富人生的領域，進而不斷追尋心靈的享受，樂在藝術美好的氛圍裡。把藝術融入生活中，藝術生活化，提升生活的品質是我追求的方向。

　　由建築出身，進而水彩畫、國畫、工筆畫、油畫，我把一身所學融合在藝術繪畫的創作中！經年累月的琢磨錘鍊，積累內心的豐富情感，渾然自成的敏銳色覺，汲取西畫的抽象精華，描繪東方的具象風味，透過細膩密緻的筆觸，結合交叉利落的刀法，鋪陳豪情膽大的色調，勾勒虛實遠近的層次，繪出生機勃發的生命，山是山、山亦非山；水是水、水亦非水；樹是樹、樹亦非樹，美妙意境自成一格，層層色彩相互呼應，遠看近觀耐人尋味，此可謂藝術創作的「最高境界」，也是我終身追求的創作目標與理念。勉勵自己做一個不斷求進的藝術創作者，期許能創作出更好的作品與愛好藝術的同輩先進及收藏家共享之。

Philosophy and Concept in Modern Art Painting

By Chan A-Shui

Artistic creation is mysterious, full of magnetic attraction and invisible magic. Painting is like composing a masterpiece in music. There are only seven primary musical notes, but with high and bass pitches, from fortissimo to pianissimo, applying fast or slow tempo, a melody can be composed, fascinating music can be played and touch people's heart without making them tired. Painting achieves the same result by utilizing seven primary colors: red, orange, yellow, green, blue, indigo and violet. After mixing these colors, various masterpieces can be created. A musical masterpiece can convey the qualities of depth, tranquility and powerfulness to soothe people's soul. Applying these elements to painting, masterpieces full of vitality and inspiration will naturally move the viewers' hearts and intrigue the viewers' mind.

In order to explore the mystery of artistic creation, to continue taking the long path of being an artist, it is important to keep an optimistic attitude and to be exposed to the sources of inspiration. In the process of artistic creation, traveling can broaden one's views and bring inspiration.

The nature is the most beautiful creation in the world. Four seasons and different climates causing the ever-changing beauty of the scenery. Therefore, by traveling and being in the nature, I can observe the rich colors of the wonders, acquire the features of the earth and rocks and record the feelings that the landscape gives me. "Calmly observe, and everything becomes self-evident ", let myself becalm and let my mind be free from worries, the inspiration will naturally emerge. Free myself from the rules set by

predecessors, I release what I feel through brushes and color mix, a particular style and beauty can be created on the canvas.

The moral of self-cultivation can be found in the process of creating art masterpieces. Painting is a static activity, it requires the quality of perseverance to continue and concentration is needed when the brush is at hand. When the realm of achievement is reached, one is unable to stop. Therefore, one can reach a worry free mood and enrich one's mind and soul through painting.

To be able to finish a satisfactory artwork is a great accomplishment and a joy in life. A Chinese saying " The journey of life has not been made in vain" can very well explain it. When I find pleasure in painting, I can naturally enhance my artistry and invisibly enrich my life. People around me are influences and they encourage me to improve my works so that I get closer to a life abundant with art. It is great to be able to continuously seek spiritual enjoyment and to be in an artistic atmosphere. Incorporate art in my daily life, art is life, life is art, improve the quality of life, is what I pursue.

With a background in architecture, I started with water painting and ink painting, then proceeded with painting with meticulous details and ended with oil painting. I transform all I learn in creating art. With years of pondering what art is, years of abundant emotions and high sensitivity in colors, I extracted the essence of the Western abstract art, adopted the elements of Oriental figurative art and boldly applied layers of colors on canvas. Through fine and delicate brush strokes, combined with neat touches of painters' knives, I outlined the virtual and the real, the far and the near. The mountain is the mountain, the mountain is not the mountain; the water is the water, the water is not the water; the tree is the tree, the tree is not the tree; the composition of color layers is like the echoes in the valley; a closer look or from a distance can both fascinate the viewers. My personal style is characterized by its vitality and energy. I call it "the Supreme Realm in Painting", which is my lifetime goal and philosophy. I want to be an art originator and I expect to improve as time goes by. I expect myself to make better artworks to share with senior artists, art lovers, and collectors.

談臺灣的抽象畫家詹阿水

文｜郭東榮 教授

台灣五月畫會創始人之一
前國立臺灣藝專（今臺灣藝術大學）美術系主任

　　2010年在台北市宏國大樓，舉辦第一屆國際的臺灣「買得起藝術博覽會」，我在博覽會上，認識了台灣當代畫家詹阿水。在欣賞詹阿水的畫作時，「水中作畫」一眼就感覺畫風很特殊，於是聊了起來。

　　當時和詹阿水交談的過程中，才知道他是利用水油分離的方式，油料在水裡，水流動的激勵，呈現出水的紋路，完成自己的創作。這樣的作品難度很高，也有很高的失敗率，作品創作過程中要有很強的掌控力，不過一旦能完成，畫作能展現出美麗的色彩和線條。

　　我和詹阿水進一步深談時，才明瞭詹阿水「水中作畫」的功力，是累績過去許多的繪畫經歷。他一開始從事建築設計圖的繪畫工作，曾經畫過設計圖、平面圖和外觀圖。他之前也畫了很多大型壁畫，例如台北市立動物園恐龍館內的壁畫（侏儸紀公園），以及「國立臺灣博物館」內牆壁畫。詹阿水早期擅長於傳統繪畫的靜物、風景、人物等，繪畫基礎扎實，這也是他後來能創作出非同凡響抽象油畫作品的原因。在詹阿水的創作裡，賞析者能感受到大地宇宙間豐富的生命力，進入美好的想像空間，體會到生命如樂章的律動。一件看似簡單的作品，其中的奧秘是高深難測，仿佛在燦爛色彩中悠然倘佯，令人流連忘返。

　　個性直率、開朗、豁達的詹阿水，透過創作表現其思想理念以及抒發情感，畫作呈現虛實

相生並融合中西繪畫的特色，抒情浪漫中帶有抽象風格，為藝術做了全新的解讀，展現出一種無與倫比的視覺震撼和色彩詮釋。

詹阿水從事繪畫創作 50 年來，在藝術領域裡，秉持著不斷探索研究和嘗試的心態，不停追逐自我的成長，從不懈怠。他的作品風格獨特及新穎創新，表現上又帶有科學家的探險精神，因此作品也頗受肯定，是當今畫壇上不可多得的巨匠，在台灣當代藝術家領域上具有很高的地位。

Talk About the Taiwanese Abstract Painter, Chan A-Shui

By Professor Kuo Tong-Jong

Managing supervisor of the May Art Group
Former Chief of the Department of Fine Arts, NTUA

It was in 2010, when the First International Taiwan Affordable Art Fair was held in Hung Kuo Building in Taipei that I met Chan A-Shui. When I was appreciating Chan A-Shui's paintings, I found the style of "Painting in the water" very special and so I went on chatting with him.

During our conversation, I discovered that the paintings were made by the oil-water separating method. He puts oil paints in water and the force of the water creates wrinkles, he uses these wrinkles to create paintings. This kind of work is very difficult and the failure ratio is high. The artist needs to be very controlled during the creation of artworks. As long as it can succeed, the beautiful colors and types of lines can be presented on the canvas.

After we talked further, I realized the reason for his competence in "painting in the water" was that he had accumulated many years of painting experiences. He started from an architectural drawing job and used to draw architectural designs, floor plans and architectural appearances. He also did large size wall paintings such as the "Jurassic Park" stage sceneries for the Dinosaur Hall of the Taipei Zoo and the inside wall paintings of the National Taiwan Museum. In the early stage of his painting career,

Chan A-Shui specialized in classical paintings such as still life, landscape, portrait sketching and figure and gesture drawing. The solid foundation of his painting skills contributed to his ability to create the extraordinary abstract artworks in the later stage of his painting career. In Chan A-Shui's artworks, the viewers can feel the power of life in the universe, it is like entering into a wonderful space of imagination and experiencing the beautiful musical movements of life. His paintings look simple but they are actually full of depth and richness as if wandering in those colors which gives people an unforgettable memory.

With characteristics of simplicity, cheerfulness and open-mindedeness, Chan A-Shui presents his ideas and expresses his feelings through his artworks. His paintings outline both the virtual and the real, synchronize the Oriental and the Western styles and embodies the abstract style in its romantic emotions, demonstrating a new type of art of marvelous visual excitement and color expressions.

During his 50 years painting career, Chan A-Shui never stopped discovering, searching, trying and making progress in the field of art creation. His artworks have their special style and are full of creativity. They present the scientist's adventurous spirits and therefore receive people's admiration. Chan A-Shui is an unique painter and acquired a high status among contemporary Taiwanese modern artists.

超越西方繪畫的詹阿水油畫

——統合抽象與具象的現代油畫登上世界藝術的峯巒

文｜李聰明教授

文化大學教授、知名書法家

　　作者有幸於四年前與上古藝術公司結緣。在上古公司陳列的畫作中，詹阿水的現代油畫，非常引人注目。油畫是繪畫藝術的主流，源遠流長，成為藝術世界的代表。詹阿水的油畫是抽象化的構圖形式，色彩極多巧妙，細看起來整個畫面又具體地說明著（表現著）一個至為巧妙的實景，他真的已經把抽象與具象結合起來構造畫面，加上他的特殊技法，把油彩調勻得巧奪天工。當我初次見到他的油畫時，我覺得這種油畫不是人用手畫的，而是天造的。由於敬佩詹阿水油畫成就，當我與詹大師相識之後，我就直接告訴他，說他的油畫已超越西方，開創油畫新紀元，將成為世界藝術史上的里程碑。詹大師很謙虛，不相信我的話，於是我往文化大學圖書館借出 Art of the 20th century（註一）和 Art since 1900（註二）兩部新書，內有上千幅的現代西畫，一幅一幅和詹阿水的油畫作比較，想找出現代西方名畫有那一幅是比詹阿水的油畫優秀的。我們真的找不到有優於詹阿水的畫作。詹大師的心才穩定下來，相信我說的話有真實性。

註一： Art of the 20th Century by Ruhrberg Schneckenburger. Fricke Honnet. VoLumel painting.1998.Printed in Germany.
註二： Art Since 1900 modernism antimodernism postmodernism by Hel Toster Rosalind krauss Yve-Lain Bois.Beniamin H.D.BachLoh First published in United Kingdom in 2004 by Thames & Hodson

傳統的西方繪畫，畫的是真實的具象、明暗，層次、比率、嚴格實在，畫得越像越好，它的珍貴在逼真生動，這樣的畫風從古希臘羅馬相沿直到 19 世紀末期印象派。（Impressionism Painting），大發於法國，畫家開始走出畫室到大自然的日光照射下作畫，日光下看到的印象是什麼就畫出什麼來。法國的革命，美國的獨立，帶來自由的思想，這種自由思想給印象派畫家開始大胆的揮動自由的畫筆，到印象派後期，像凡谷（Vincent Van Gogh）的畫風把外在的大自然加上他內心的衝動，畫出了凡谷獨有的畫。從事印染的馬諦斯（Henri Matisse）緊跟在印象派後期，也受到自由主義的影響，在彩色上作了大胆的變革，明明人的面孔是粉紅白晰的，但馬諦斯偏偏要把人的臉色畫成綠色的，諸如此類，馬諦斯的畫面所用的色彩與構圖大異傳統作風，表現奇特而又粗曠激烈，記者與評論家把他的畫風稱為野獸派（Fauvist Painting），這是構圖，彩色，明暗上，突破傳統繪畫的法則，也是傳統具象繪畫轉向抽象繪畫的第一個突破。

接著畢卡索（Pablo Picasso）把實在的人面或物體景物予以解構破碎（Collagy）創出立體派（Cubism），傳統的寫實具象被解構打破，再創出奇特引人好奇的立體繪畫（Cubist Painting），這是西方傳統繪畫向抽象繪畫的第二個突破。

20 世紀初，一個俄羅斯茶商的兒子康定斯基（Wassily Kandinsky）到德國學法律，但他對繪畫有興趣，轉學藝術，學德國的表現主義（Expressionism) 雖有意識表現，但還不會超脫具象畫的規格，只在具象畫裡要求表現而已，於是他一反傳統提出新的藝術理論，指出像繪畫表現應該是畫內心的東西，把內在的心思表現出來，所以他正式提倡畫內在的抽象的繪畫理論（Abstract painting）。康定斯基的抽象理論與 20 世紀風起雲湧的自由主義不謀而合，抽象畫就此在歐洲風行起來，傳遍全世界。

剛好第一次世界大戰軍國主義帝國主義的威權霸道與戰爭的殺戮殘酷，使得歐洲斯文掃地。很多畫家反對霸權獨裁，紛紛聚集到瑞士，以反霸權、反戰爭、反權威、反傳統為主張，唱出達達主義（Dadaism），達達主義一出那些原來只有畫實象才能登大雅之堂的畫法，也一併被達達主義者的反權威反掉，這麼一來，抽象畫的自由作風，便成為更具有地位的藝術立場。

心理分析學家佛洛伊德（Sigmund Freud）的潛在意識心理分析夢幻知覺，予以當時正在樂得發揮自由的前衛畫派加油加醋，而以超現實主義（Surrealism）作畫派流傳。第二次世界大戰結束，美國成為世界自由主義的領導者，紐約成為世界的經濟重心，畫商從法國的巴黎移到

紐約，歐洲的畫家也紛紛移居紐約，50年代，紐約開始取代巴黎成為世界的藝術中心，從歐洲來的現代主義畫家們與紐約的自由主義畫家如傑克遜泊洛克（Jackson Pollock）等人合作起來成為紐約派，他們的主張既抽象又表現，因此成為第二次世界大戰後的最大畫派叫做抽象表現主義派（Abstract Expressionism）。他們以紐約為中心，因此又被稱為紐約派。

紐約派是徹底的抽象畫派，因為他們的抽象表現，既無主題又無形象，很多人看不懂，令觀眾們懷疑這是否藝術。紐約派在1950年代興起到60年代末，為迎合觀眾的要求，出現市場導向大眾流行的普普藝術（Pop Art），譬如畫面有貓王或瑪麗蓮夢露或商品廣告等，即使蒙娜麗莎加上鬍鬚也被接受，像這樣的普普藝術（Pop Painting）雖然大眾化了，但是卻成為低級俗氣的畫作。

接著文化人類學（Cultural Anthropology）對藝術唱出視覺效應的人類美學觀，80年代後，因之有歐普藝術（Optical Art 簡稱 OP Art）出現。歐普藝術以視覺效應為主軸，其抽象畫表現看重如何吸引人的視覺效果，結果缺少繪畫的入味美感。也走不出藝術的峯巒。於是觀念主義（Conceptual Art）的藝術出現。觀念藝術注重主題而又表現出社會現實感，因此在抽象的畫面上加上文字文句或名言，使藝術品富有觀念主導，這已顯得20世紀自由主義引導出來的抽象繪畫走到極限。極限主義（Minimalism）的畫家在畫布上塗滿紅色，沒有其他圖象，而把這一幅畫命題為"熱情"，讓觀眾站在一片紅色的畫面前體驗熱情的感思，這是多麼形上學的繪畫理論。接著地景藝術出現，畫家不用畫布作畫，而是到野外，利用地形加上很長的布條使之成為像風景又像畫面，它已有抽象與具象的結合，但它不是繪畫。

20世紀的繪畫，就是這樣演變下來走到極限，不知如何再向前一步走下去。2011年紐約出版一本"藝術現象學"（Art and Phenomenology）（註三），強調具象的繪畫世界和抽象的繪畫世界，都是一樣的屬於藝術表現，但是20世紀自由者抽象畫家排斥傳統具象畫家。既然具象繪畫與抽象繪畫都是繪畫，那麼繪畫的世界就不應該相互排斥。具象畫的寫實表現上雖不自由，但畫面上有實在的形與象。抽象畫的抽象表現上完全自由，但完全抽象的畫面，卻沒有實在的形或象，如果把抽象畫面加上實在的形或象，使抽象畫不致於變成無意義的空白（例如前述全部塗上紅色命名為熱情）如此則抽象畫已統合了具象畫。抽象與具象的統合，可以使抽

註三： Art and Phenomenology Edited by Joseph D.Parry Published 2011 by Routlege New York.

象的東西變成有意境有味道。這大概就是 21 世紀繪畫藝術應該走下去的道路（以上只作摘要轉述）。

　　但是作者至今尚未看到西方或東方的現代畫家有那一位畫家把抽象與具象統合起來的作品。詹阿水的油畫是抽象的構圖形式，細看其整個畫面又具體地表現一個實景，統合抽象與具象，而美感十足。他真是一位超越西方登上藝術峯巒的現代畫家。

Beyond the West — The Modern Art of Chan A-Shui

——His oil painting expresses the integration of abstract and figurative styles.His achievements have reached the summit of the art world.

By Professor Lee Tsung-Ming

Calligrapher
Professor of the Chinese Culture University

I got to know the Sogo Art Gallery 4 years ago. Among all the artworks displayed in the gallery, the modern oil paintings of Chan A-Shui attracted my attention the most. Oil painting has been mainstream in the long history of the art world. Chan A-Shui's oil paintings are formed with abstract compositions, the colors are rich and well placed. When you look at his artwork carefully, you will find that the whole painting obviously describes and expresses an ingenious landscape. He really has combined the abstract and the figurative in the pictorial structure. With his special technique, he is able to mix oil paints so well that his paintings look like supernatural workmanships.

When I first saw his oil paintings, I found that they were not made by human's hands but by a god. I thought highly of Chan A-Shui's achievements. After getting acquainted with him, I told him directly that his works of art had gone beyond the achievements of the western art world, that he was creating a

new era for oil painting and that his works would become a milestone in the history of art. Chan A-Shui was modest and didn't believe in my words. Therefore, I went to the library of the Chinese Cultural University and borrowed two new books, Art of the 20th century[1] and Art since 1900 [2] where there were thousands of Western modern paintings. I flipped over every page and compared each painting in the books to Chan A-Shui's paintings in order to find out which Western modern painting was superior to his, I could not succeed. Only after showing those books to Master Chan did he start to be relieved and believe in the genuineness of my words.

The classical Western painting is figurative with formal elements of light and dark, line and shape, precise scale, clearly deriving from real objects and carefully finished images that look realistic when examined closely. This type of style was mainstream from Ancient Greece and Rome till the Impressionism emerged in the late 19th century. Impressionism originated in France where a group of artists started to walk out of their studios. Under natural sun light, they drew what they saw, what the impression was. The French Revolution and the Independence of the United States brought out liberalism, which encouraged the impressionists to use their brushes boldly and freely. In the Post-Impressionism, Vincent Van Gogh's style was to include his inner impulsiveness in the landscape sketching which created his own particular painting style. The print maker, Henri Matisse, emerged after the Post-Impressionist period and was also influenced by liberalism. He started a revolution by using colors boldly, he painted the face of a woman in green without regard for her natural color. The composition of his pictorial structure and color was non-conventional, unique and wild. The critics and journalists classified his style as "Fauvist painting". He subverted the principles of the classic paintings in the aspects of pictorial structure, colors, light and dark. It was considered as a breakthrough in the development of the art history, figurative was moving towards abstract.

Later on, Pablo Picasso developed Cubism by using the collage techniques on portraits and objects. The artwork was made from an assemblage of different forms, classic figurative painting was taken apart

1: Art of the 20th Century by Ruhrberg Schneckenburger. Fricke Honnet. VoLumel painting.1998.Printed in Germany.
2: Art Since 1900 modernism antimodernism postmodernism by Hel Toster Rosalind krauss Yve-Lain Bois.Beniamin H.D.BachLoh First published in United Kingdom in 2004 by Thames & Hodson

and the unique and intriguing cubist painting was created. This was considered as a major development in the art history.

In the early 20th century, Wassily Kandinsky who was the son of an Russian tea merchant, went to Germany to study law. Because of his interest in painting, he turned to painting studies and learned Expressionism. In the expressionist painting, although the awareness of the abstract emerged, the realistic form was still visible. Kandinsky brought up an unconventional art theory, indicating that the painting should express the painter's inner experience, the inner necessity. He formally provided an explicit theory of Abstract painting. Kandinsky's theory coincided with the liberalism movement of the 20th century, Abstract painting started to become popular and spread around the globe.

Corresponding with the outbreak of World War I, the overbearing authority of the militarists and the brutal killings of the military conflicts destroyed the intellectuals. A group of artists were against the authoritarians and gathered in Switzerland, they brought out Dadaism. For many participants, the movement was a protest against the hegemony, the war, the authority and the tradition. Everything for which the figurative stood, Dadaism represented the opposite. The climate of freedom strengthened the abstract painting's status in the art history.

The psychoanalyst Sigmund Freud theorized that dreams could be interpreted and this was used by the avant-garde who developed the Surrealist painting style. When World War II ended, the United States became the world leader of the liberalism and New York City became the economic capital of the world. The art dealers moved to New York from Paris, the European artists also settled down in New York. In the 50's, New York City replaced Paris as the new center of the art world. The modernists from Europe and the liberalism artists from New York City began to coalesce into a cohesive stylistic group which was known as the New York School. Jackson Pollock was a major figure in that movement. Their manifesto promoted the aesthetic perspective of abstraction and the act of creation. After World War II, the Abstract Expressionists became the biggest art group.

The New York School represented a totally abstract school. It took art-making beyond any prior

boundary, paintings were non-objective and non-figurative. Viewers did not get the idea and many doubted if it was really art. From the mid 1950s, Pop Art emerged as a market oriented mass culture. In order to please the mass market, pop art employed aspects of popular culture, such as images of Elvis Presley and Marilyn Monroe, images of commercial products, advertising designs and Mona-Lisa-with-a-mustache. Although Pop painting was more accepted by the masses it became mundane work.

Afterwards, Cultural anthropology suggested that art should have an aesthetic visual effect. In the late 1980s, the emergence of the Optical Art (Op Art) was a style of visual art, utilizing optical illusions. This type of art lacked aesthetic results and its development was limited. Then, the Conceptual Art appeared, focused on ideas or concepts and expressed a sense of social reality. The utilisation of written texts or remarks on abstract paintings made the artworks full of dominant concepts. The art movement in abstract painting which was led by the liberalism in the 20th century continued its development and brought out Minimalism. Minimalist artists colored the canvas in red without any image and called it " passion". The viewers stood in front of a red color-field painting and experienced the feeling of passion, it was metaphysics in art theory. The art movement continued and was followed by Land art. The painters did not use a canvas at all, they for instance covered the ground with long strips of cloth to make it like a landscape and a picture at the same time. It had the concept of abstract and figurative combined but it was not a painting.

The art movement evolved all the way to the end of the 20th century, I don't know what may come next. A book called "Art and Phenomenology"[3] was published in 2011. It emphasizes that both figurative and abstract are forms of art, but the liberal abstract painters of the 20th century rejected the classical figurative painters. Since the figurative painters and the abstract painters are both part of the art world, they should not reject each other. There is no freedom in the realistic expression of figurative artworks, but there are concrete shapes and images. There is total freedom in abstract artworks, but the abstract pictures have no concrete shapes or images. If we add concrete shapes or images in an abstract painting, then it is not a meaningless blank (as mentioned above in the example of the red colored painting called

3： Art and Phenomenology Edited by Joseph D.Parry Published 2011 by Routlege New York.

"Passion"). In this way, the abstract painting includes the figurative painting, a combination of the abstract and the figurative concepts, which makes abstract art meaningful and aesthetic. This probably shall be the continuation of the art movement in the 21st century.

(The above is only a brief description of the book).

So far, I haven't seen any artwork done by a modern artist in the West or in the East integrating the abstract and the figurative styles well. The picture construction of Chan A-Shui's oil painting is nonfigurative, but the whole work expresses a conspicuous landscape if you look at it closely. His artwork combines the concepts of abstract and figurative well and brings out a complete aesthetic feeling. He is really a modern artist whose achievements have gone beyond the West.

火星上的水痕

2008年
20F　(73cm×60.5cm)

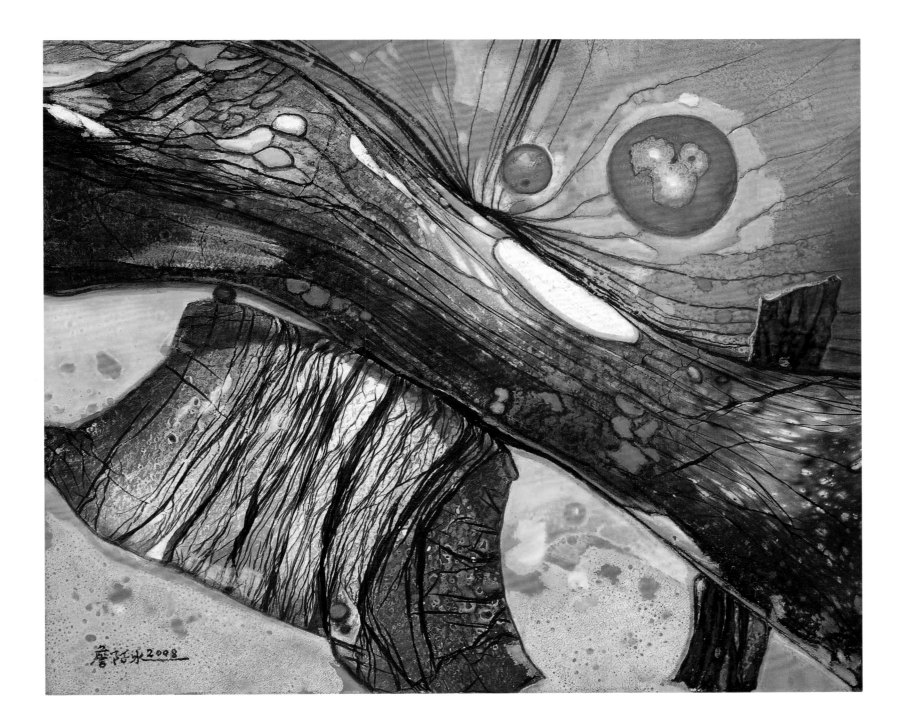

抽象（二）

2011年
20F （73cm×60.5cm）

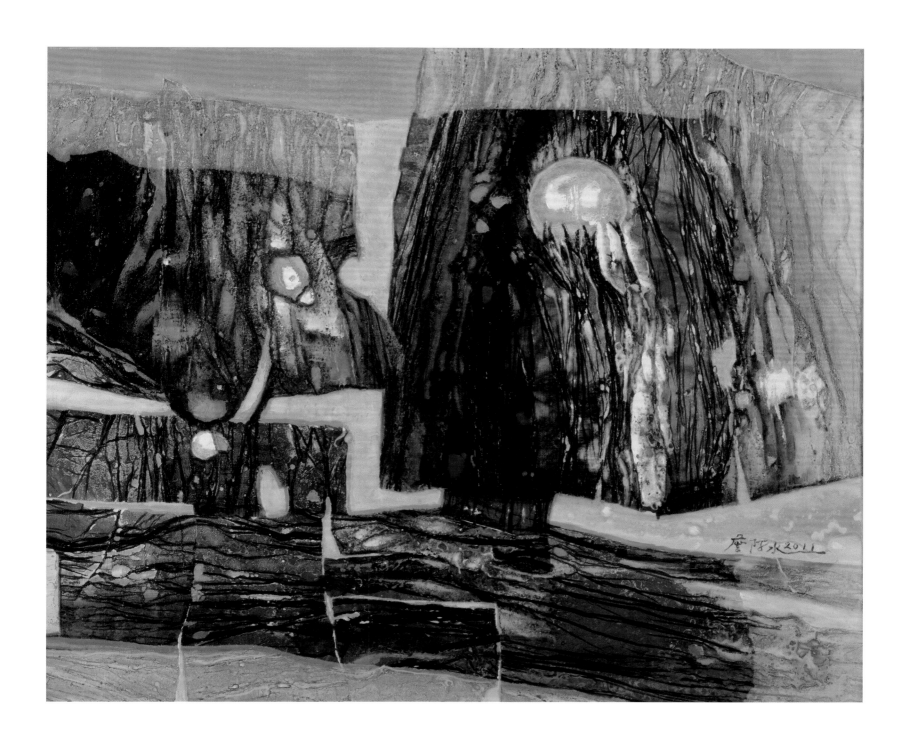

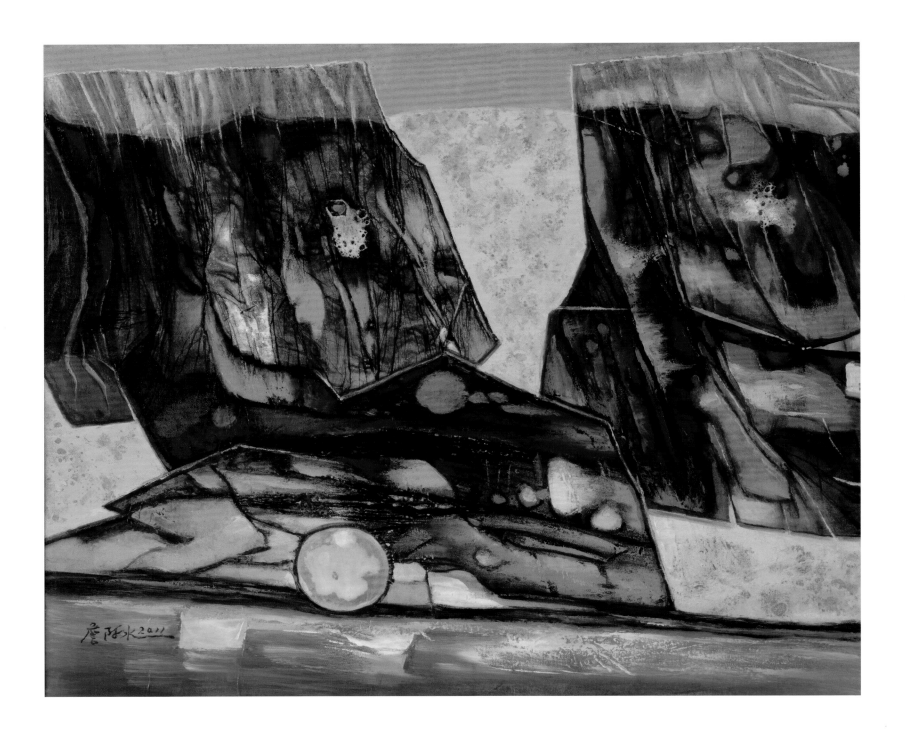

抽象（一）

2011年
20F （73cm×60.5cm）

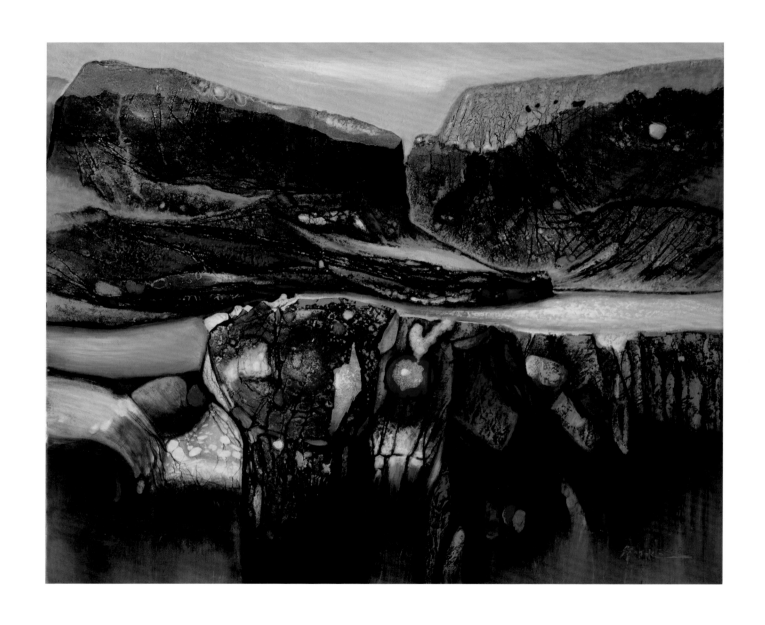

遠郷

2008年　20F　(73cm×60.5cm)

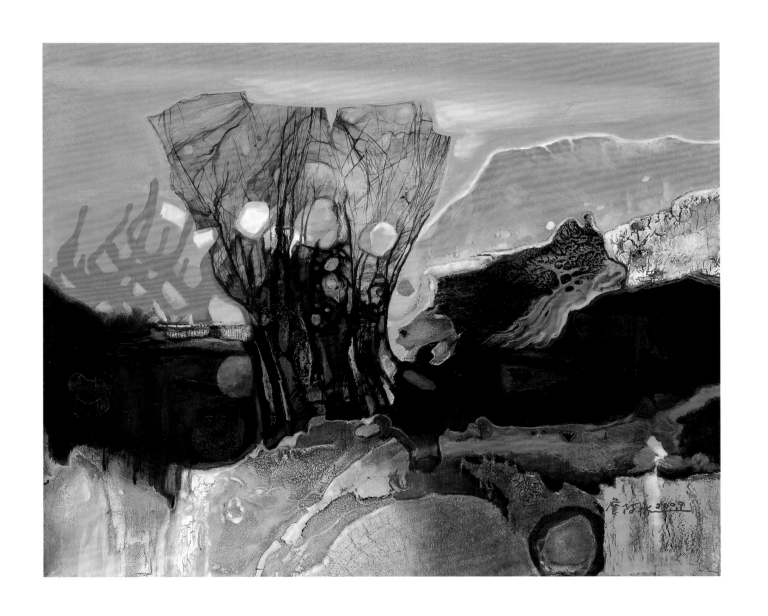

亭亭玉立

2009年　15F　(65cm×53cm)

萬像

2006年
50F （117cm×91cm）

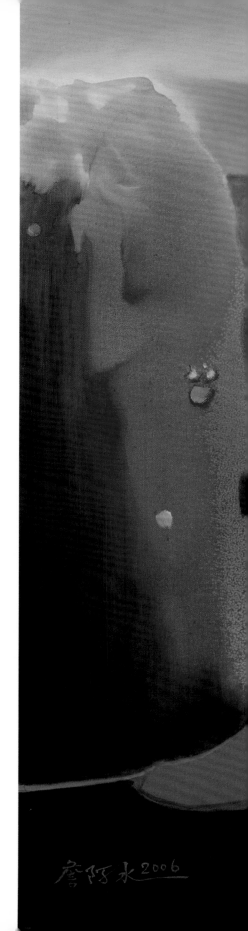

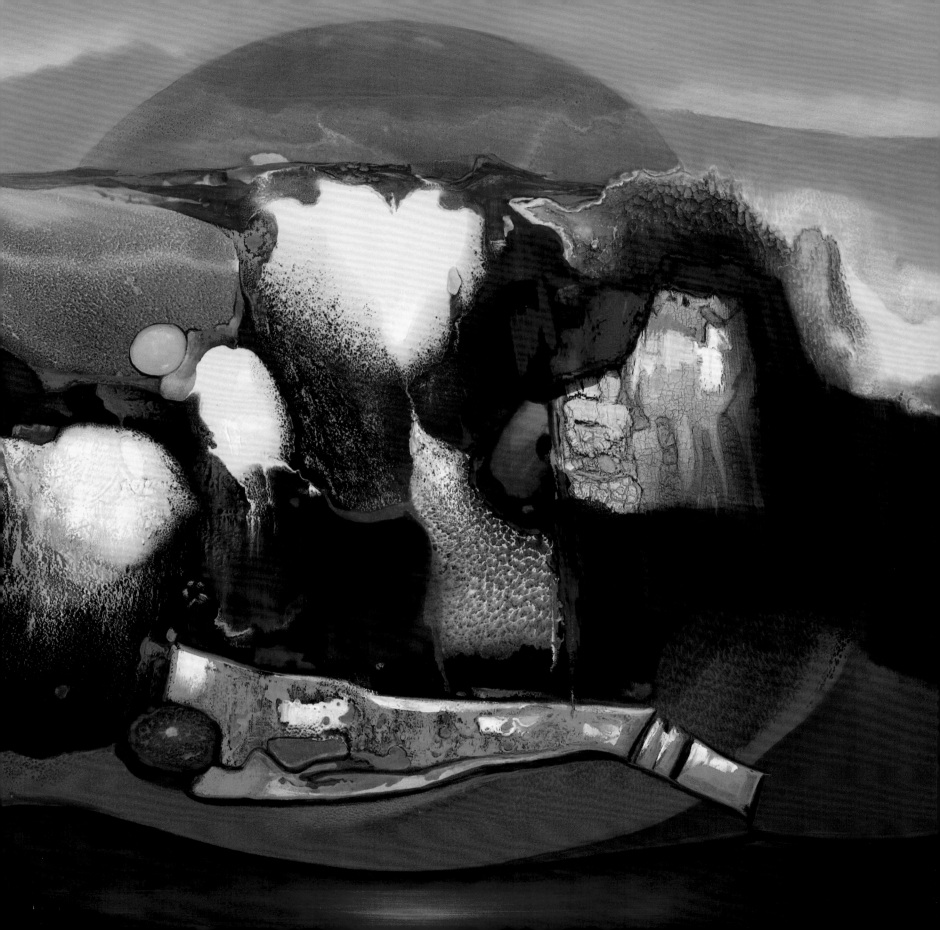

月下相伴

2013年
15F　(65cm×53cm)

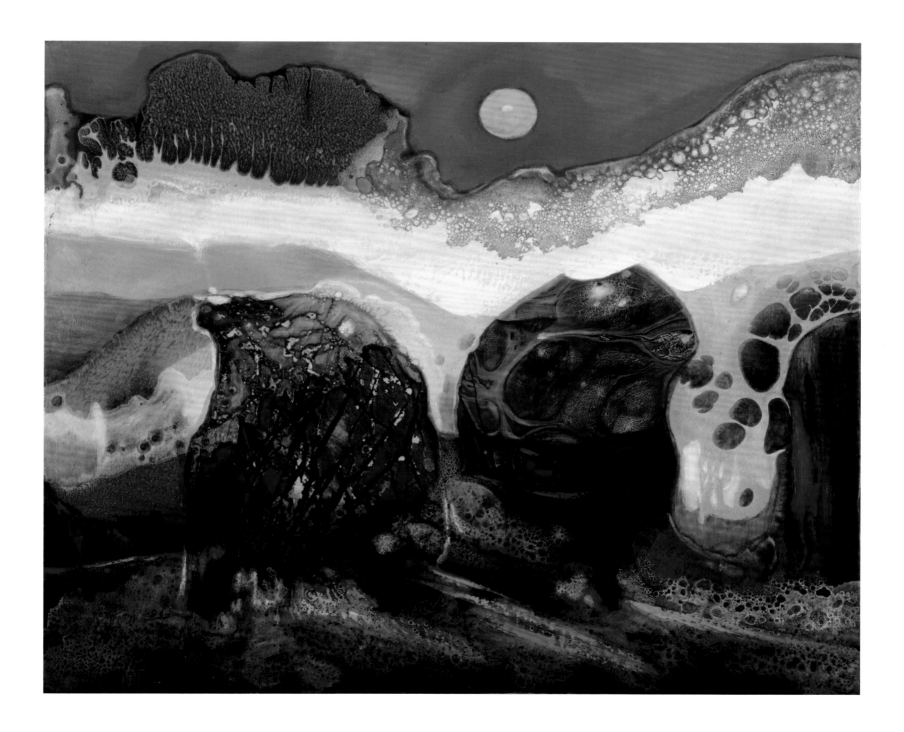

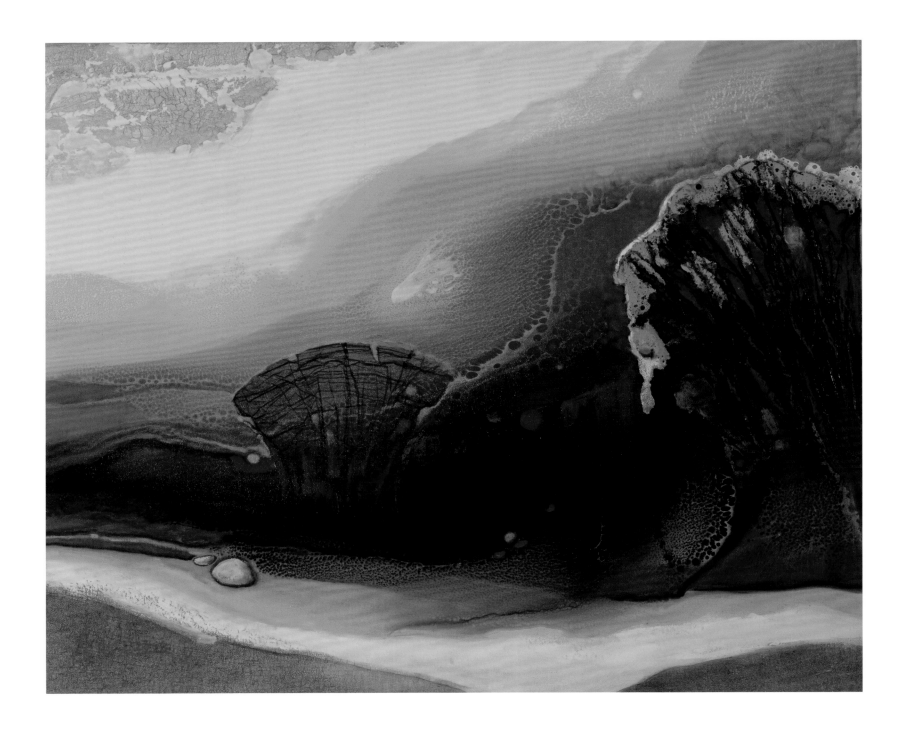

寒山秋晨

2008年
20F　(73cm×60.5cm)

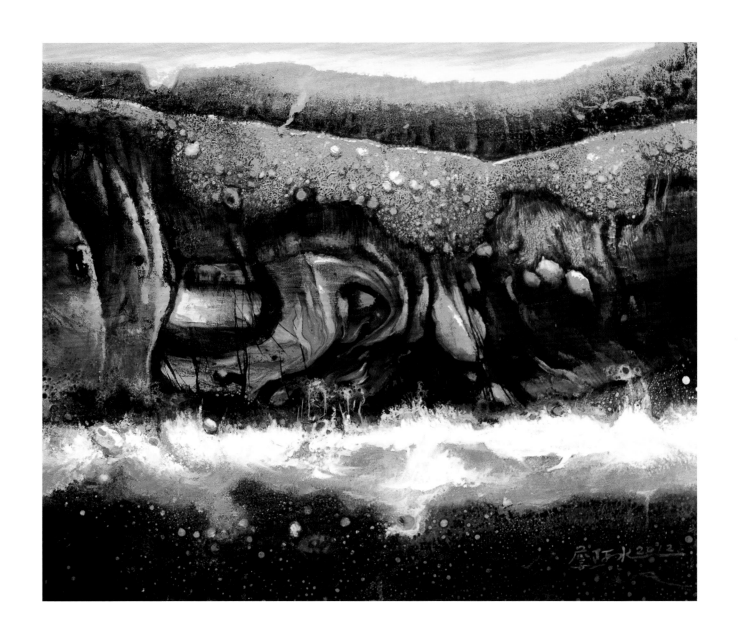

黃金峪

2012年　10F　(53cm×45.5cm)

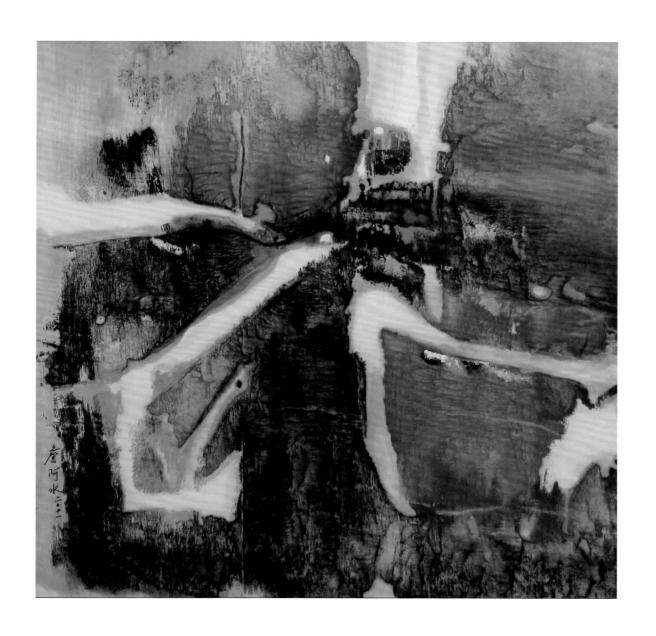

水田

2001年　15F　(53cm×53cm)

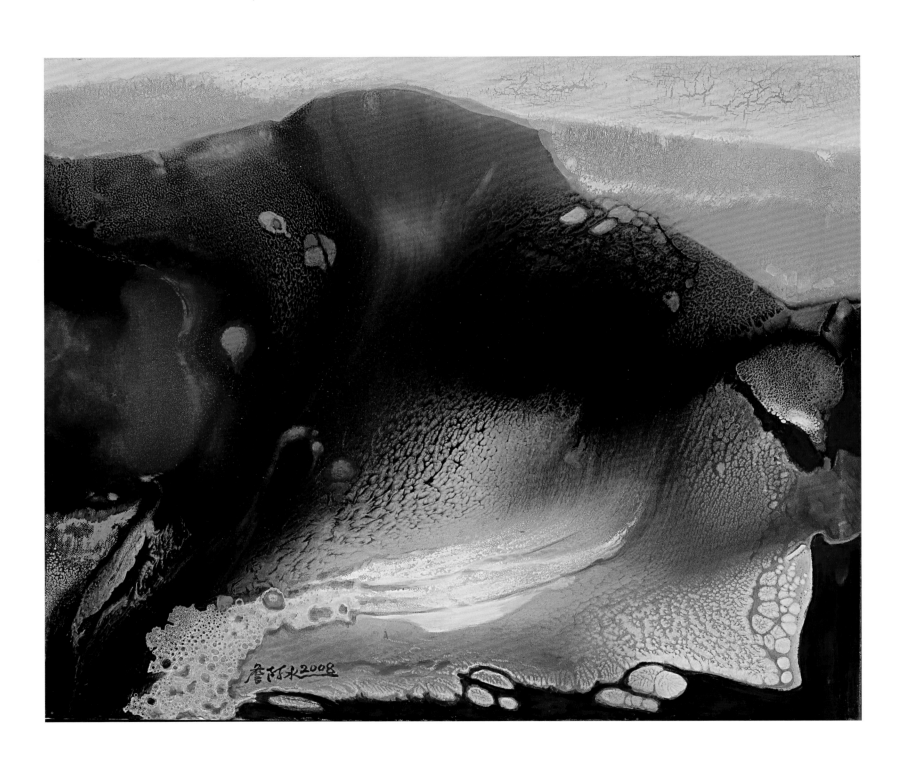

潮

2008年
20F　(73cm×60.5cm)

山嵐清境

2012年
20F （73cm×60.5cm）

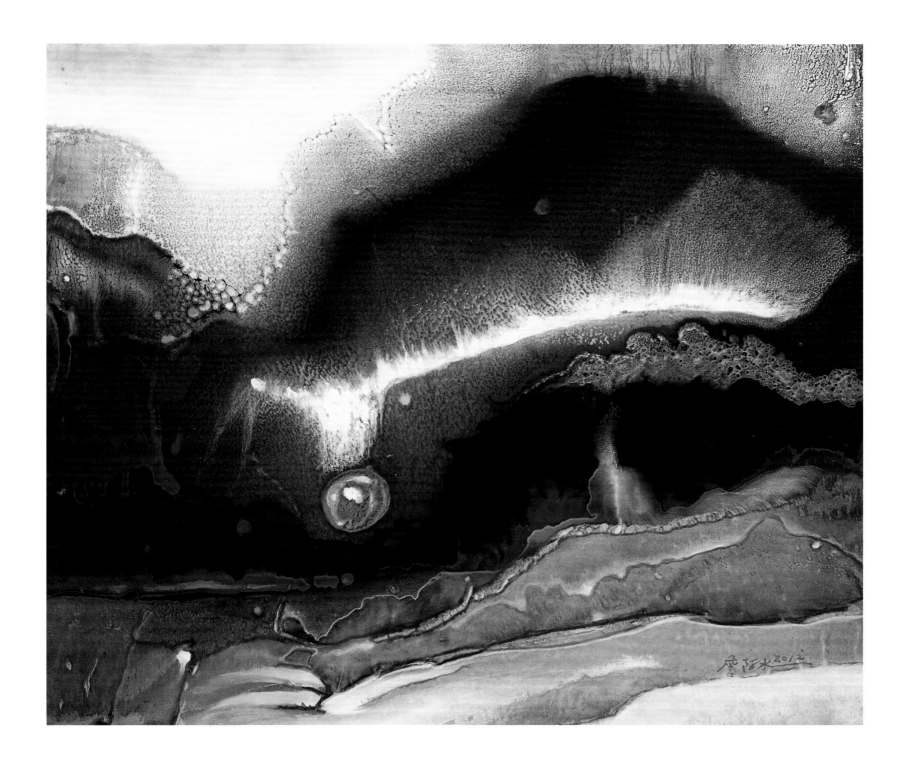

瞻光景藝

2013年
20F　(73cm×60.5cm)

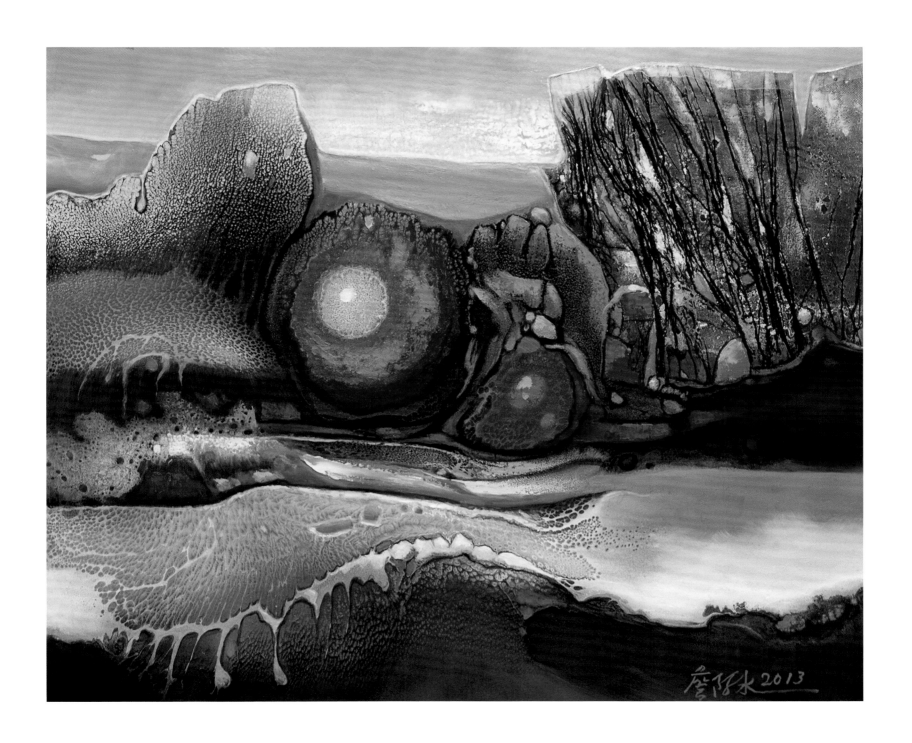

秋山風情

2012年
30P （91cm×65cm）

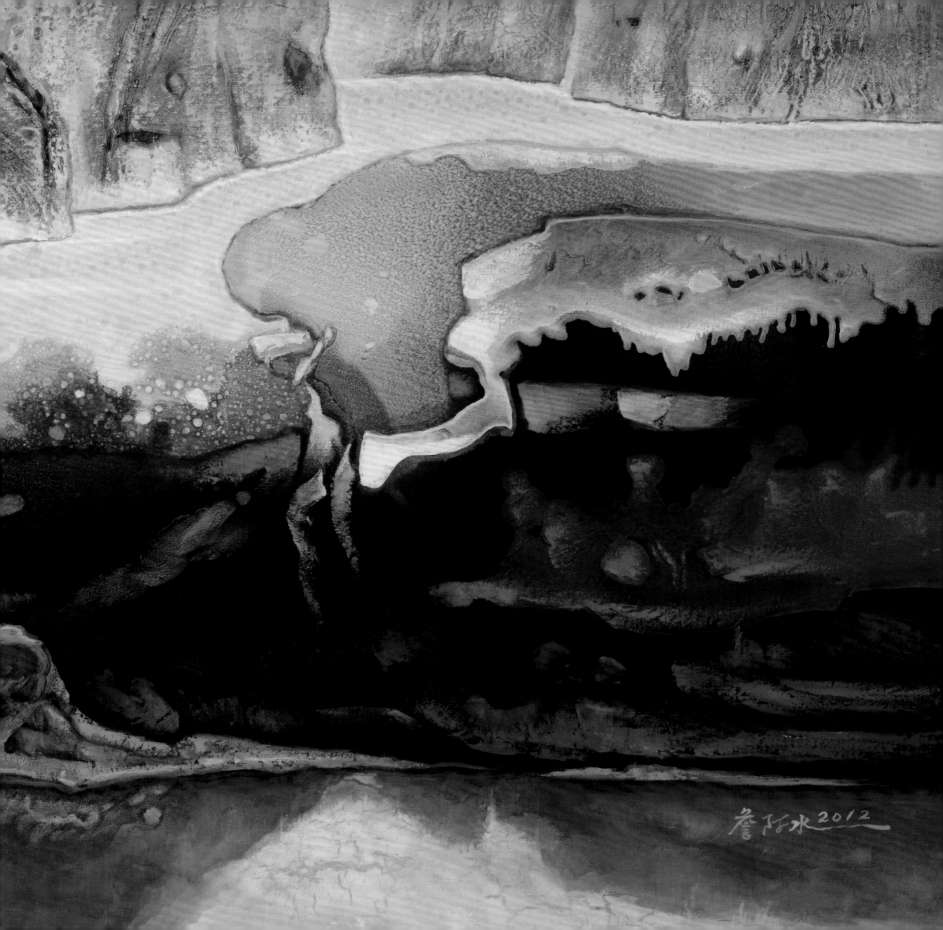

龍吟祕境

2012年
25P　(80cm×60.5cm)

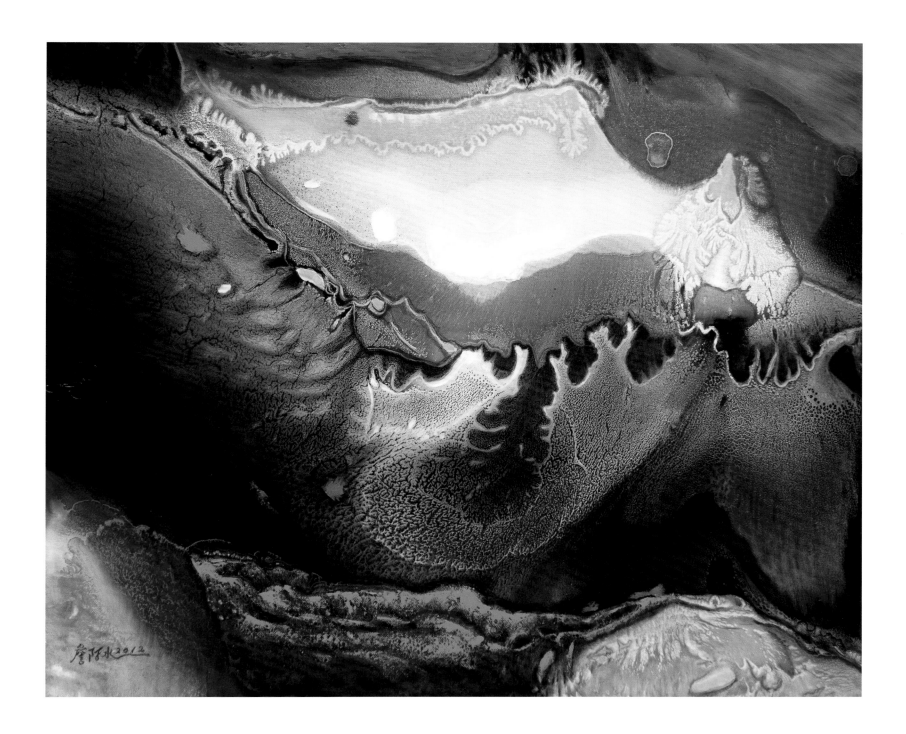

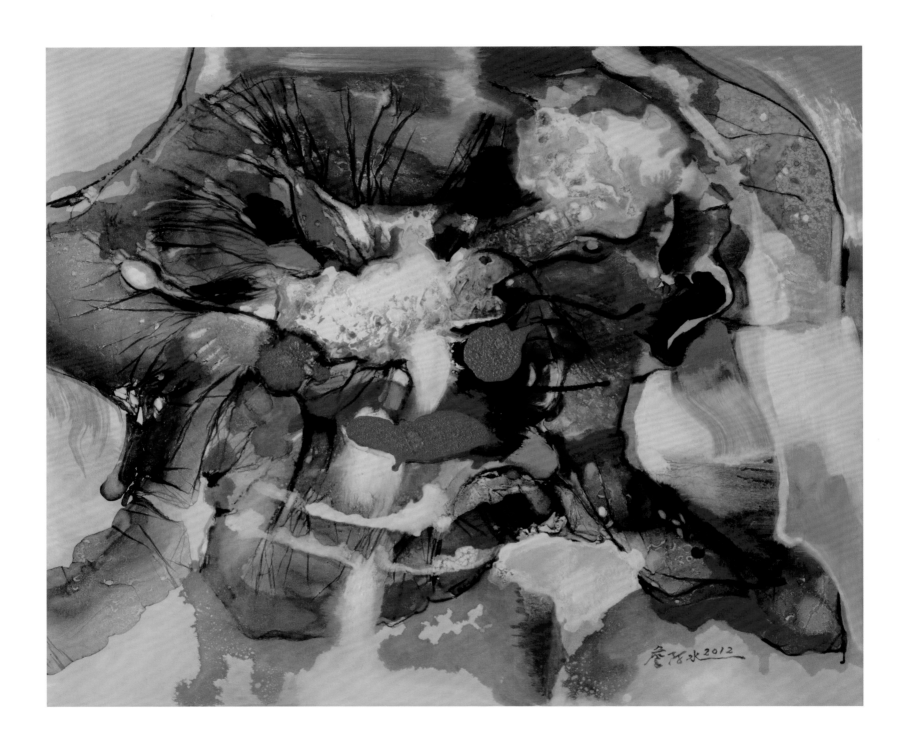

小丑

2012年
20F　(73cm×60.5cm)

協 調

2006年
40F　(100cm×80cm)

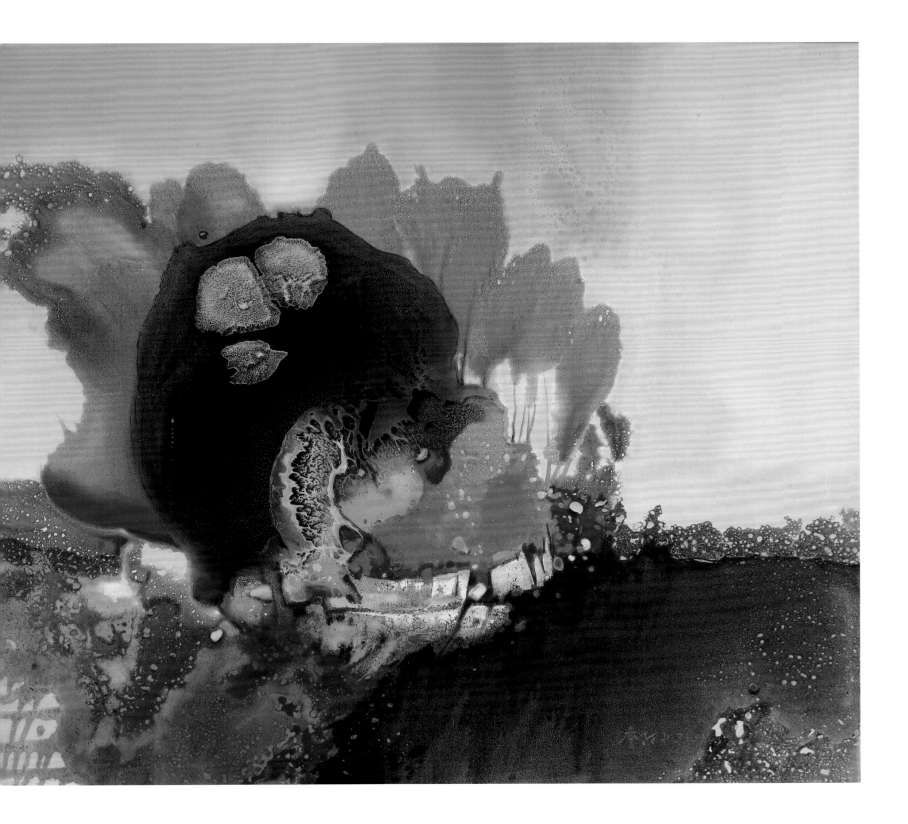

秋

2006年
15F （65cm×53cm）

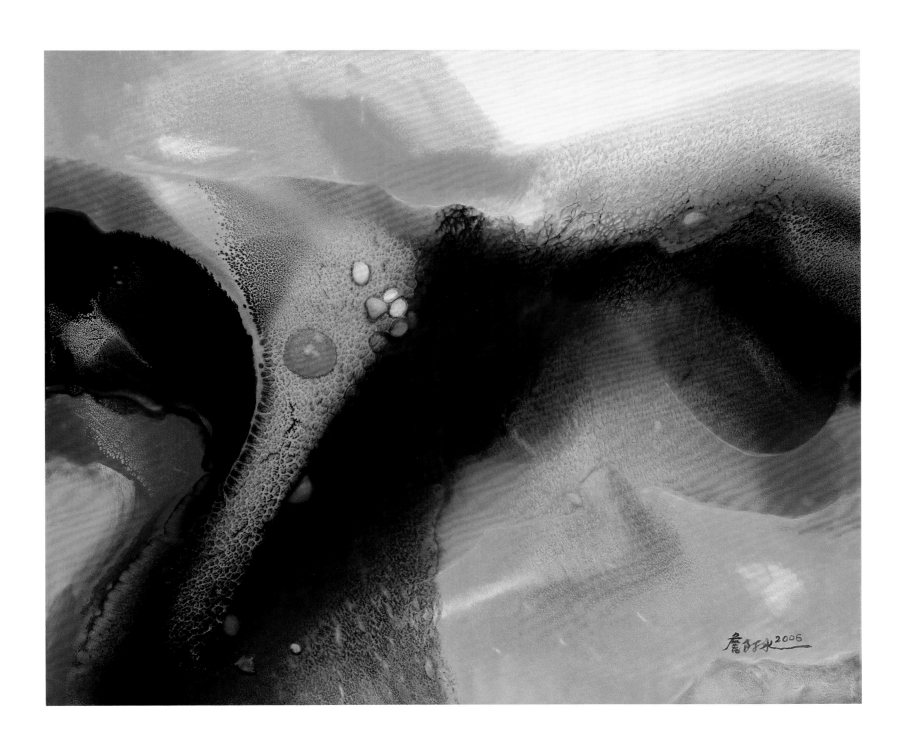

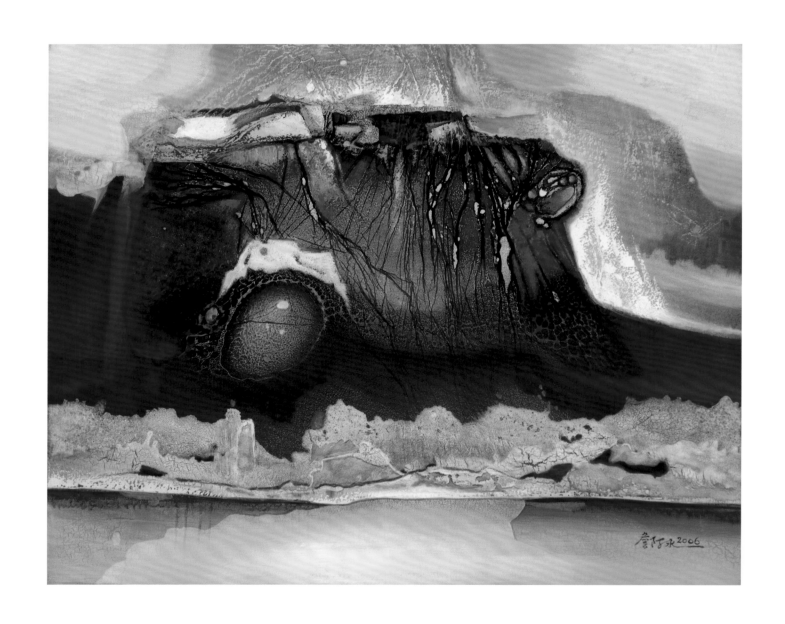

歐境高原

2006年　40F （100cm×80cm）

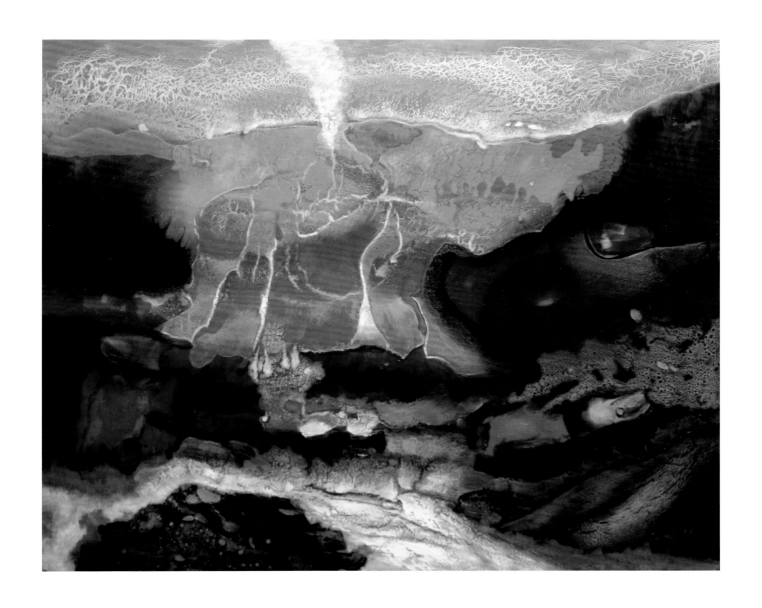

暖春

2012年　30F　(91cm×72.5cm)

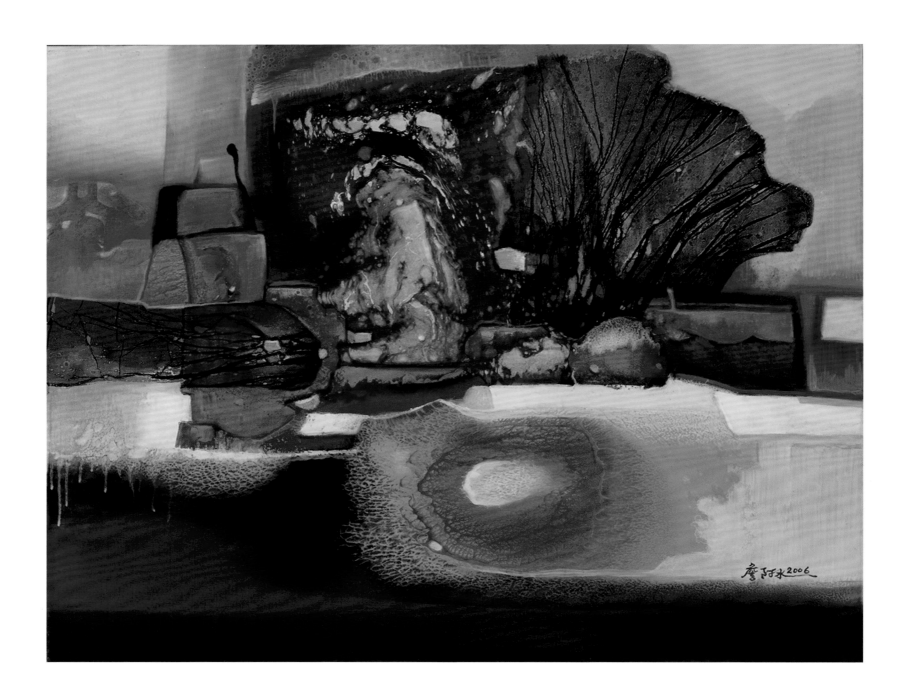

夏日

2006年
30F （91cm×72.5cm）

藍寂

2009年
30M　(91cm×60.5cm)

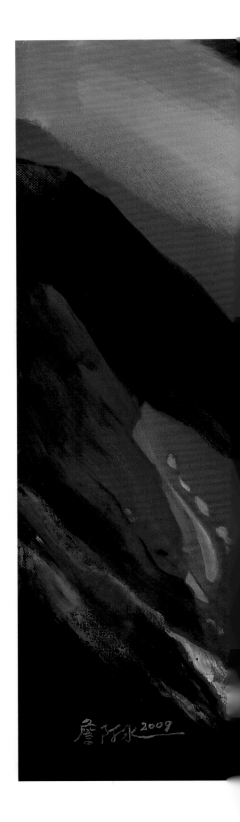

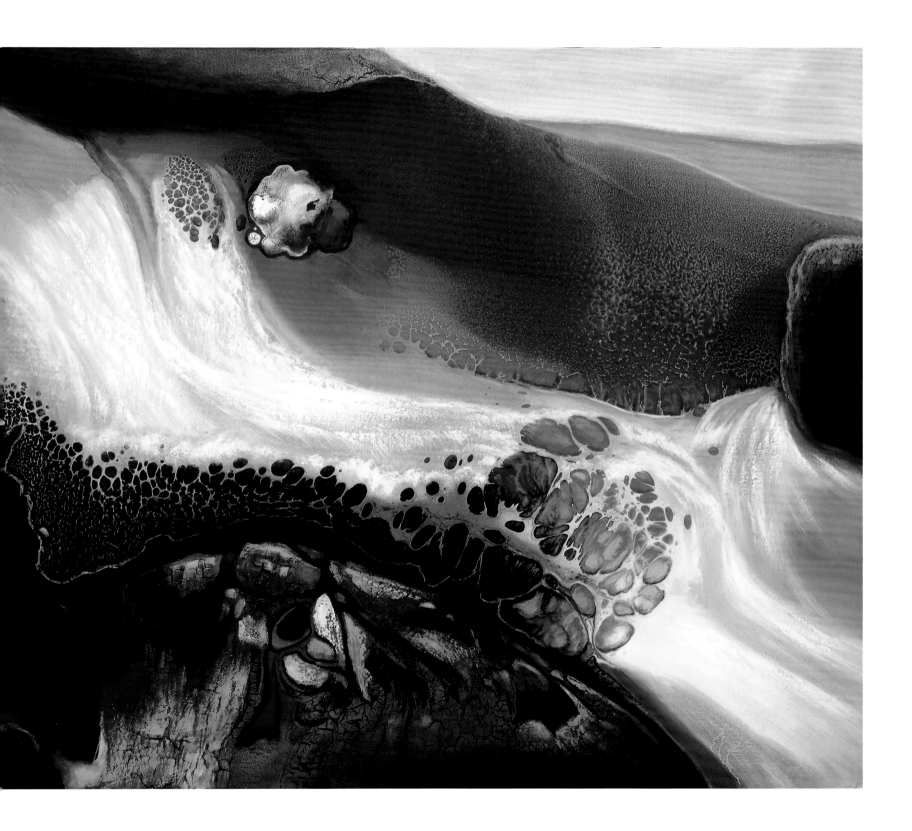

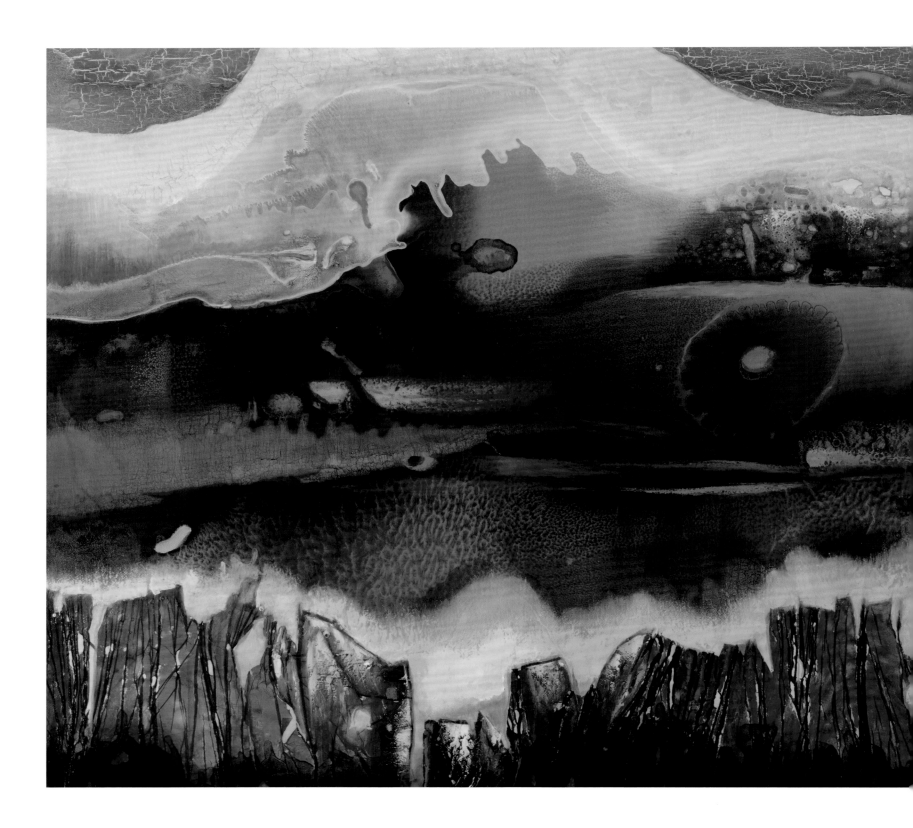

武夷山曉

2013年
30M （91cm×60.5cm）

冰晨

2006年
30F　(91cm×72.5cm)

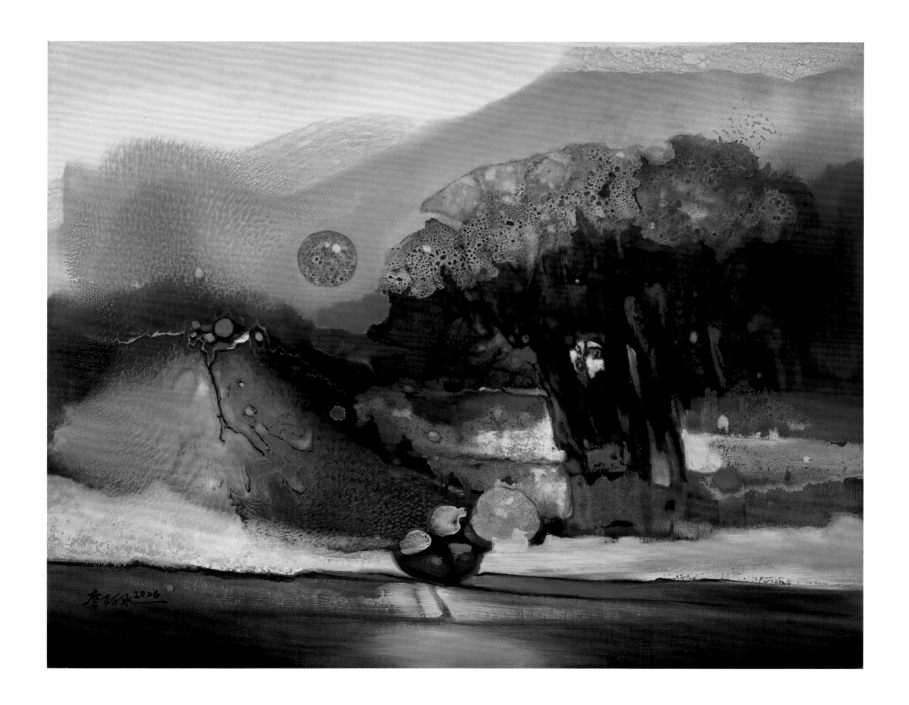

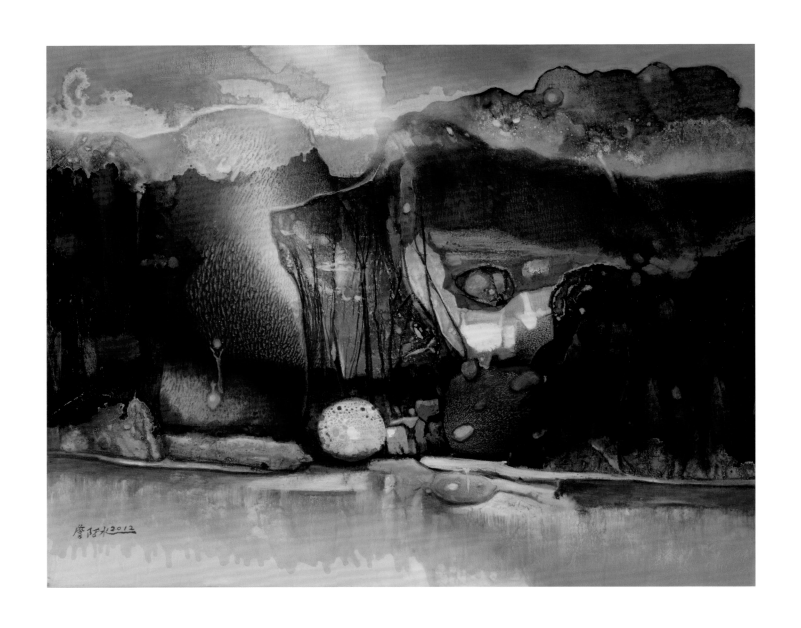

雲起山川

2012年　30F　(91cm×72.5cm)

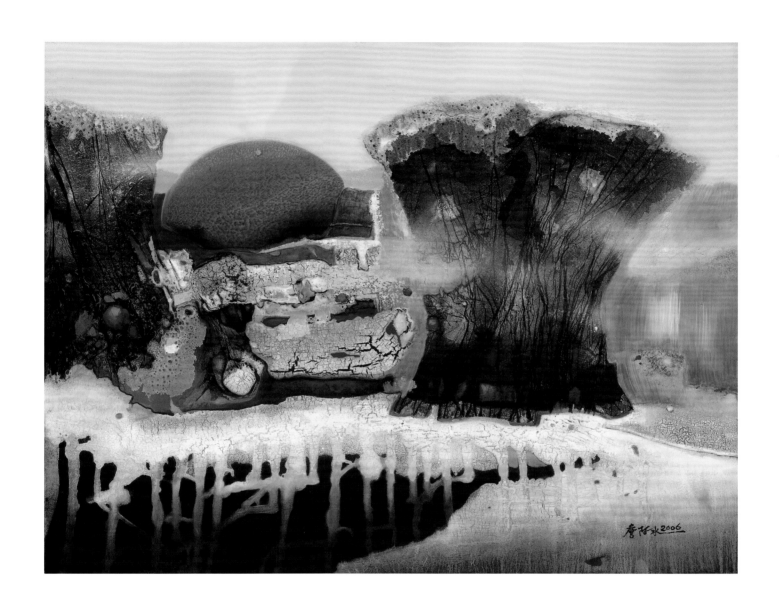

霧境

2006 年　40F　(100cm×80cm)

奧萬大之秋

2012年
30M （91cm×60.5cm）

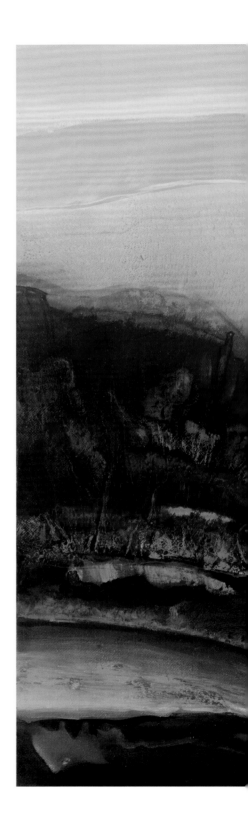

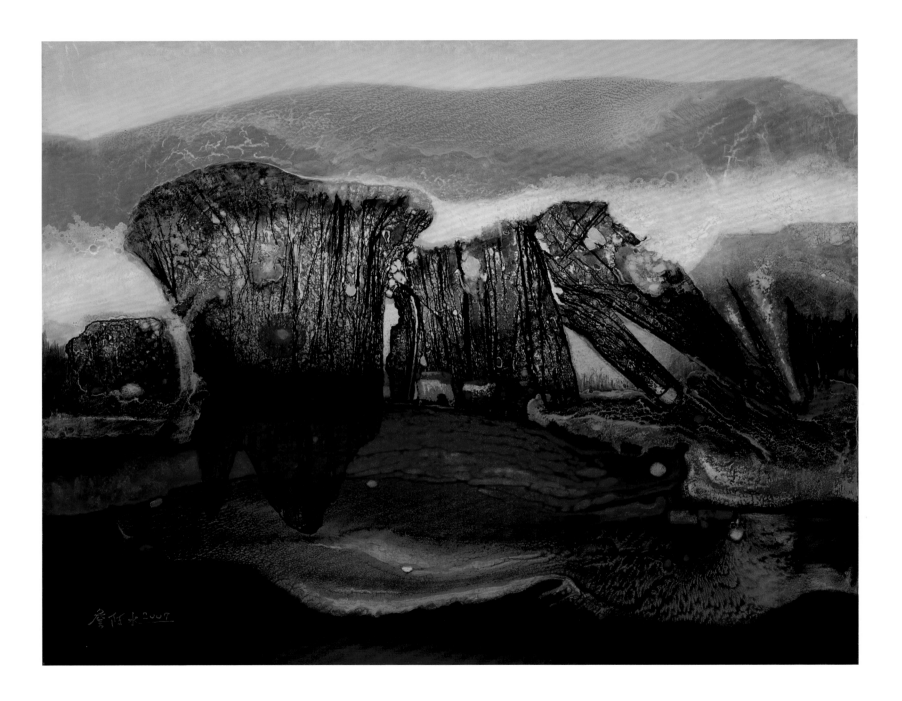

同心協力

2007年
40F （100cm×80cm）

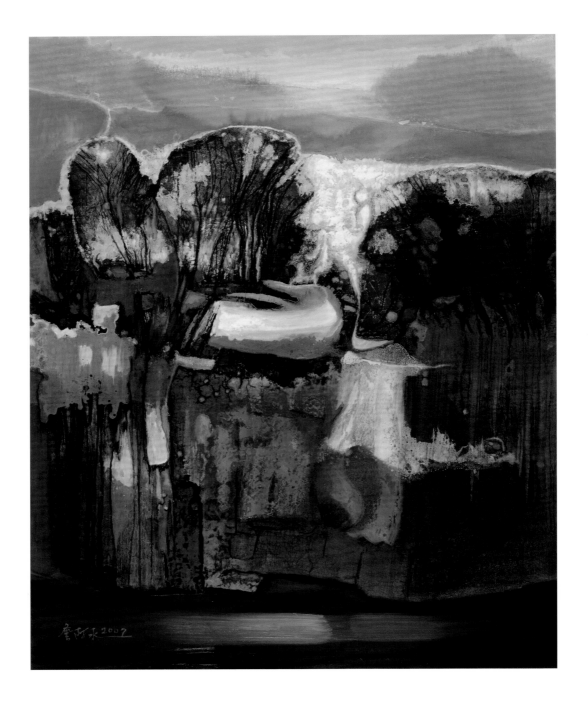

山水情懷

2007年　40F　(80cm×100cm)

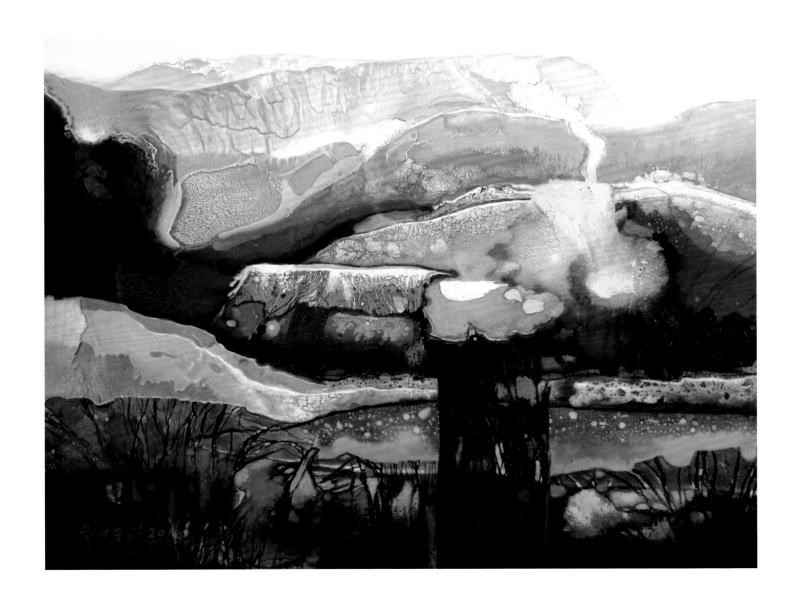

湖光憶象

2013年　50F　(117cm×91cm)

遠山懷情

2013年
30F （91cm×72.5cm）

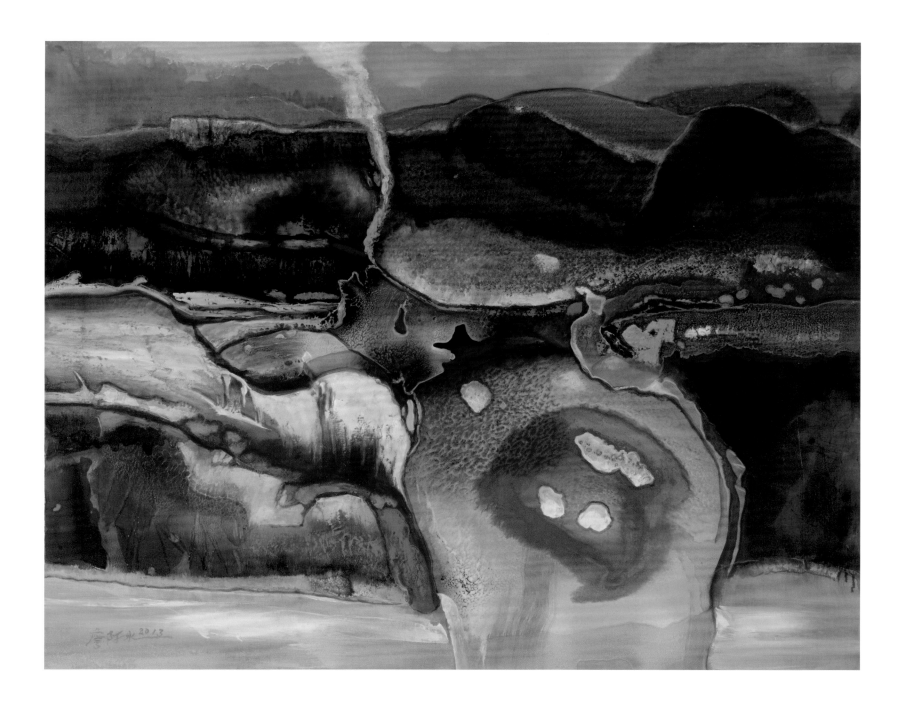

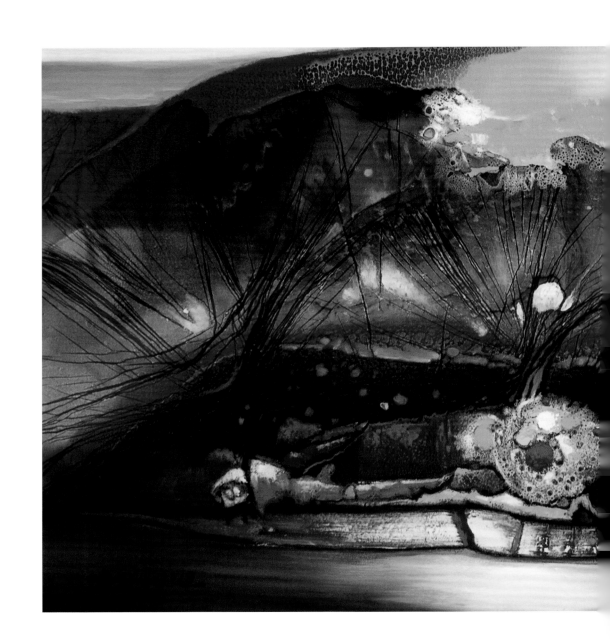

靈山情思

2013年
50M　(122cm×62cm)

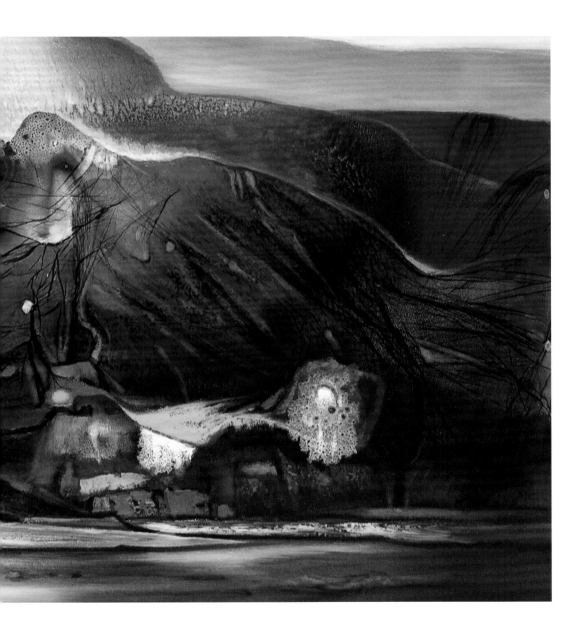

祥

2006年
30F （91cm×72.5cm）

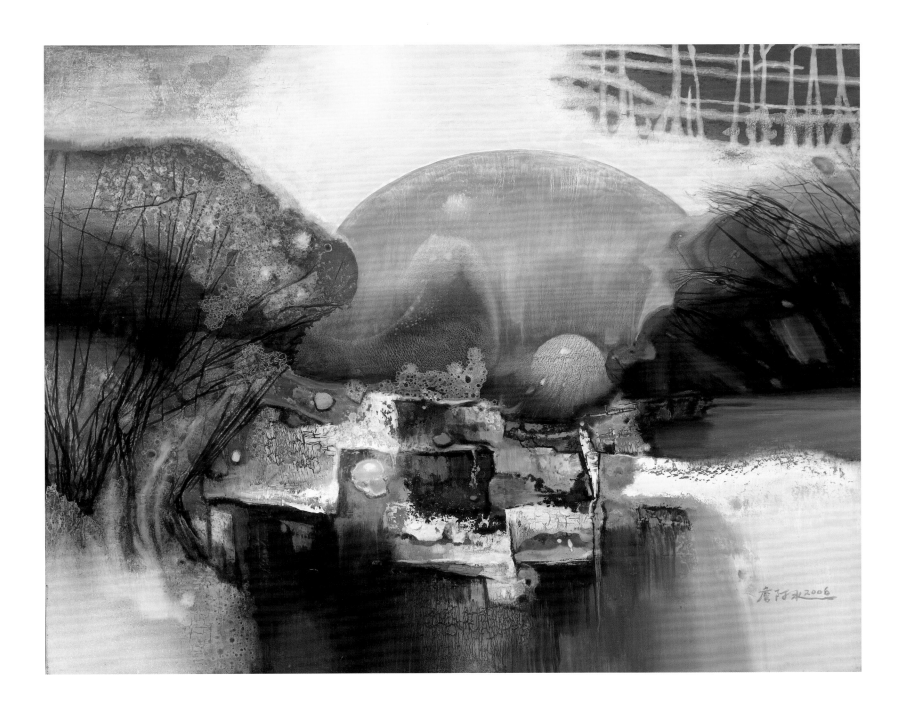

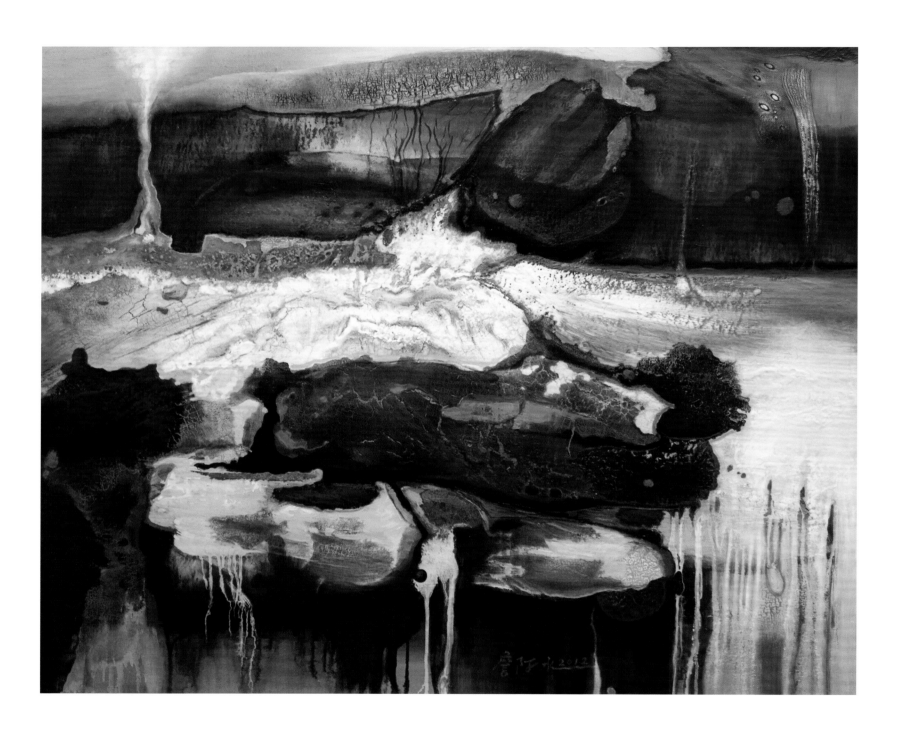

水長瀦

2012年
30F　(91cm×72.5cm)

曙光

2007年
30F （91cm×72.5cm）

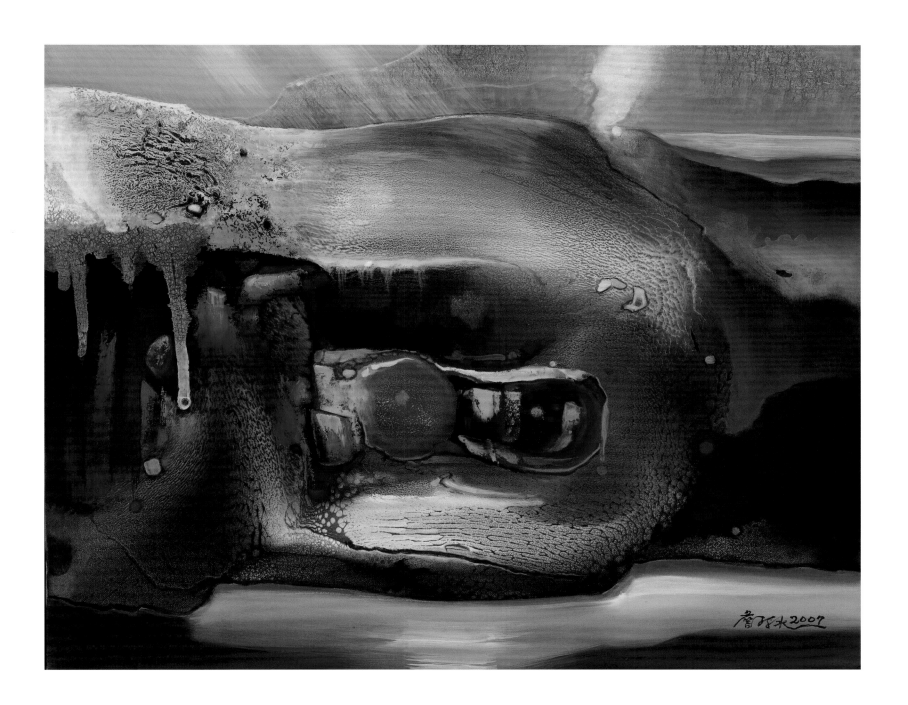

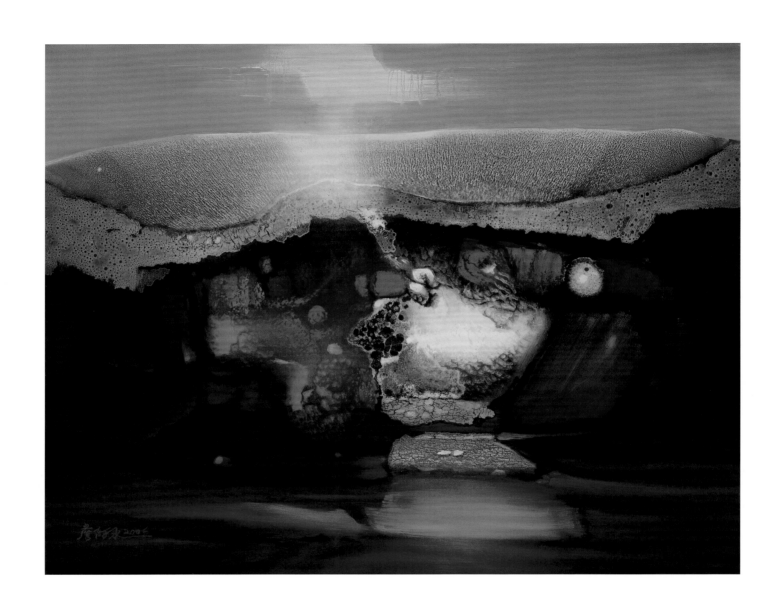

曙光乍現

2006年　30F　(91cm×72.5cm)

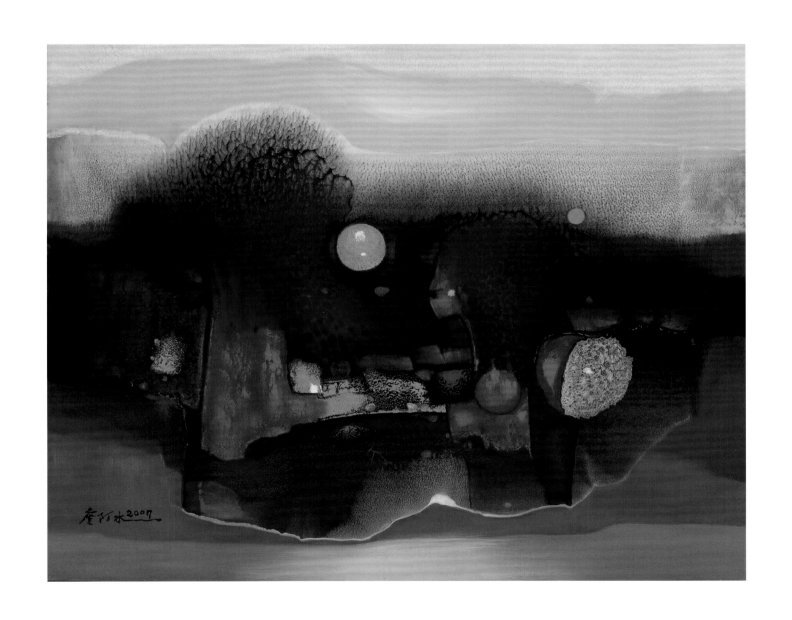

喜瑪拉雅山

2007年　30F　(91cm×72.5cm)

隠

2007年
30F　(91cm×72.5cm)

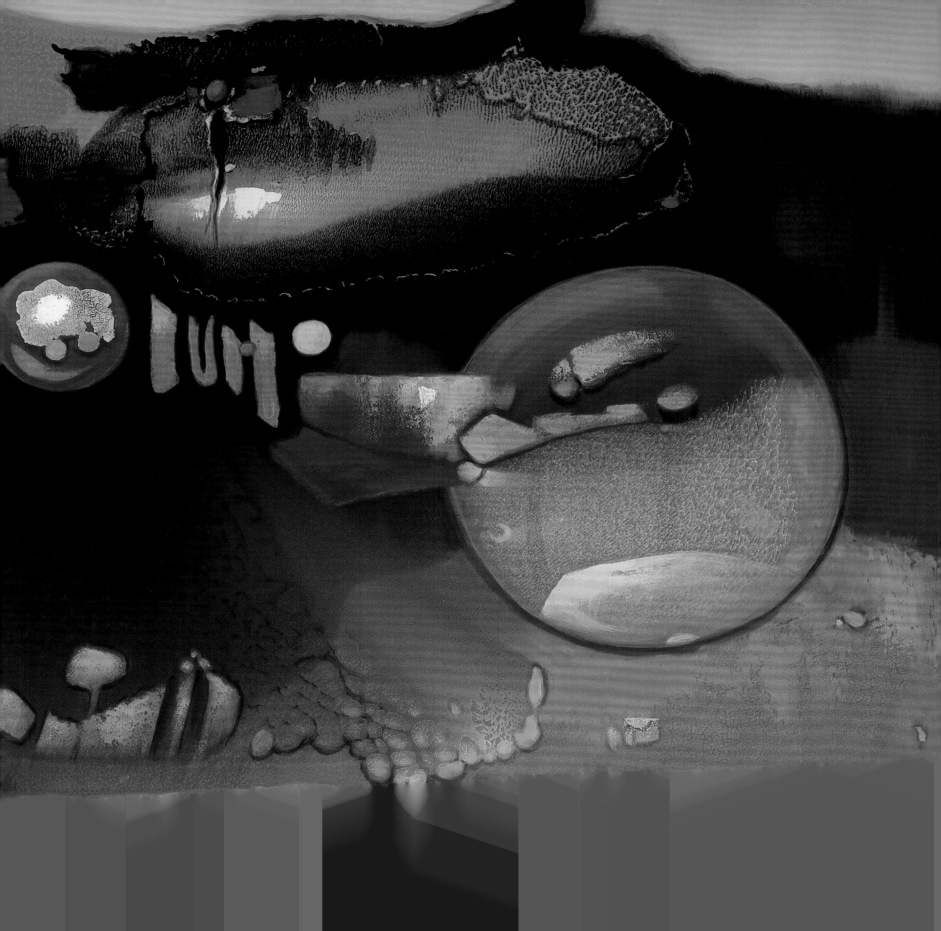

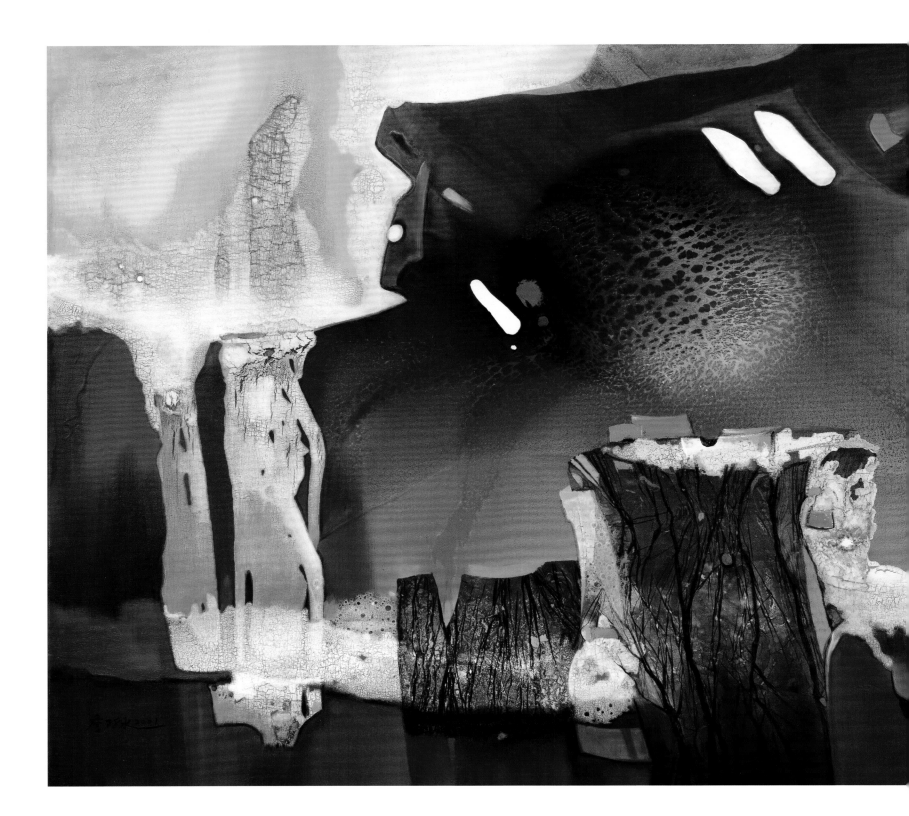

湖泊

2001年
60F （130cm×97cm）

情思長悠

2012年
30M （91cm×60.5cm）

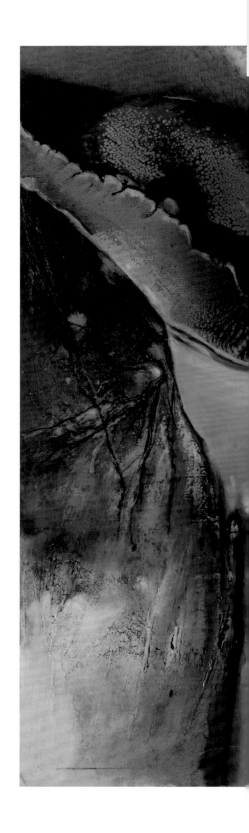

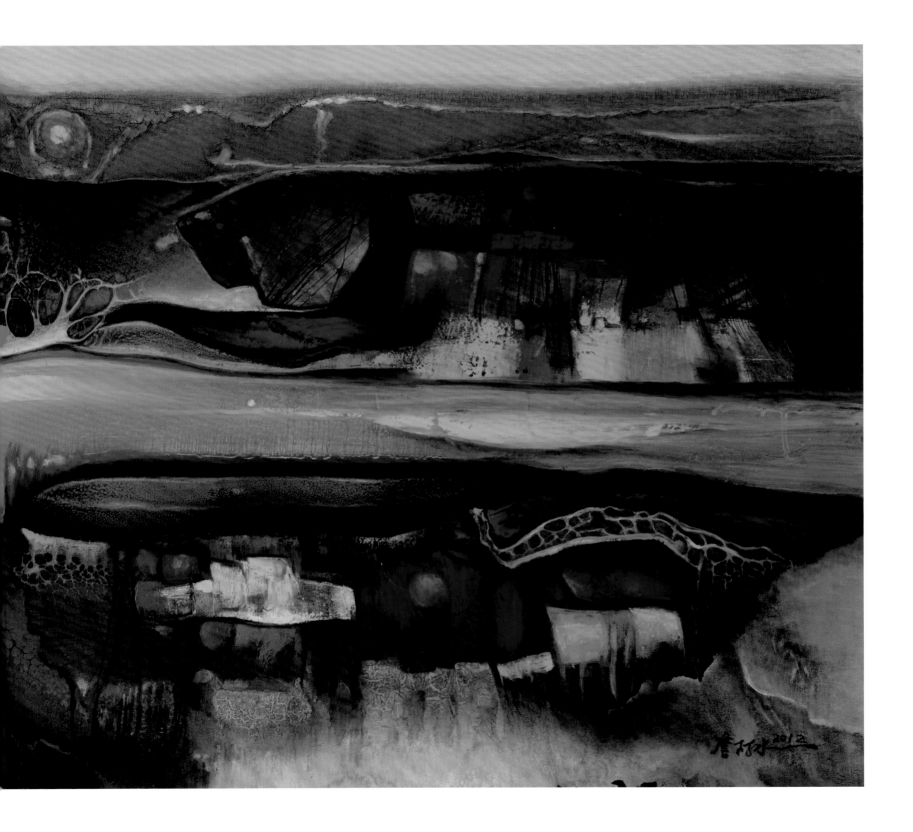

天山

2007年
60F　(130cm×97cm)

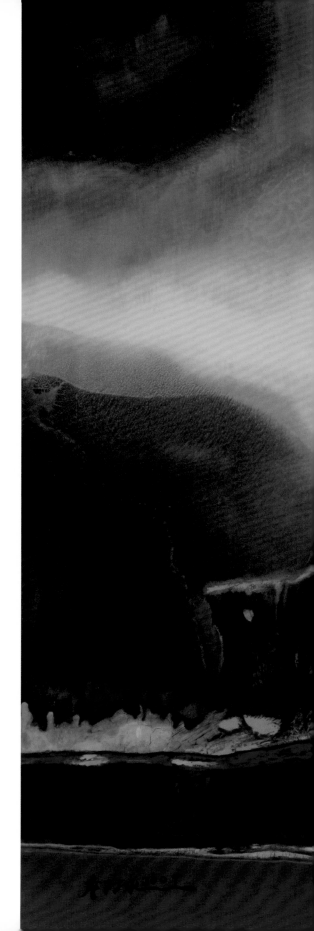

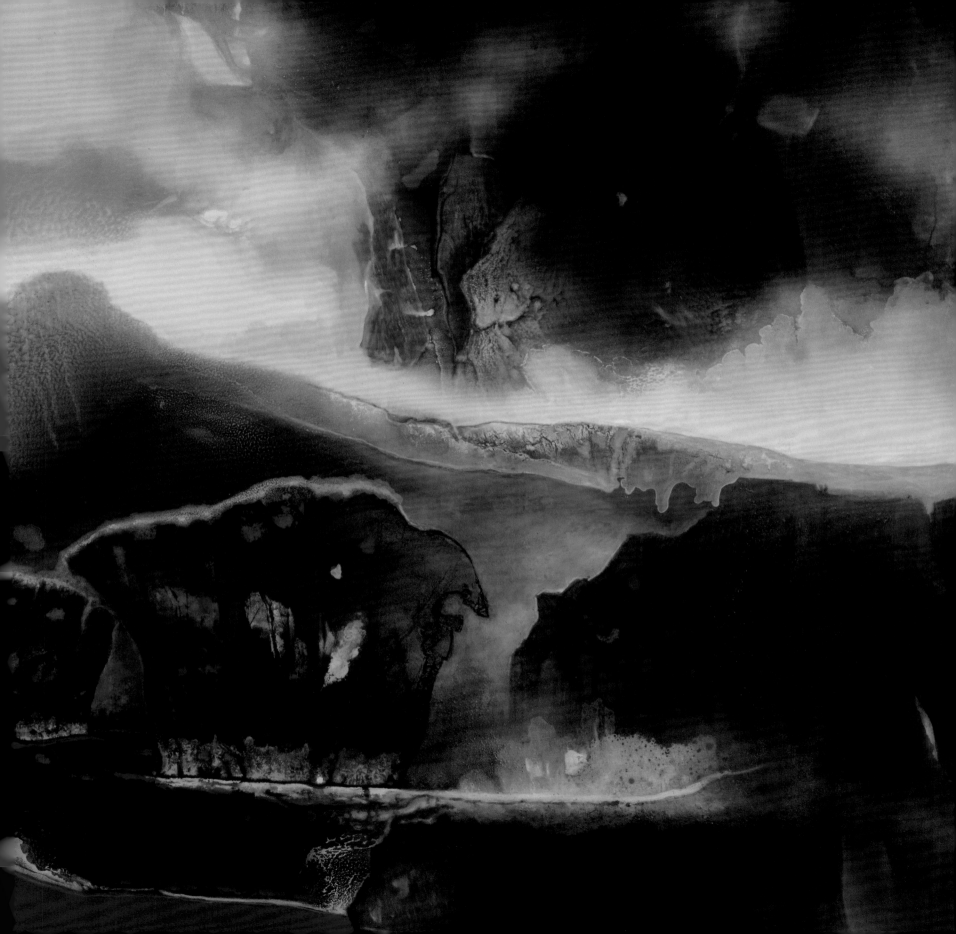

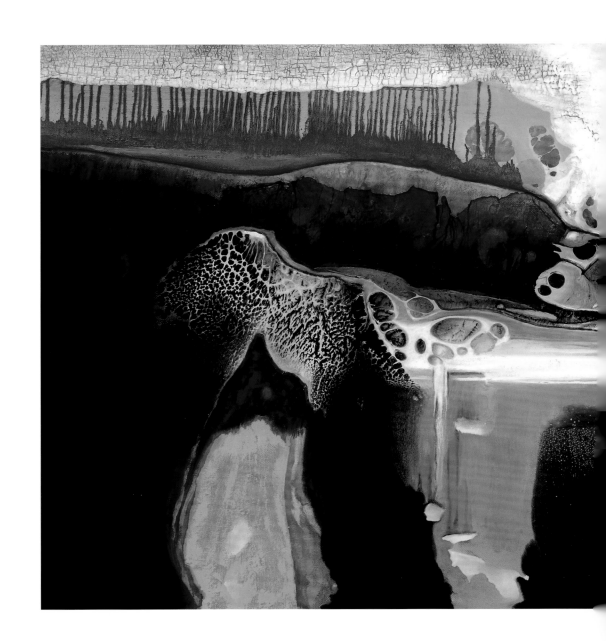

峽谷

2009年
50M （116.5cm×91cm）

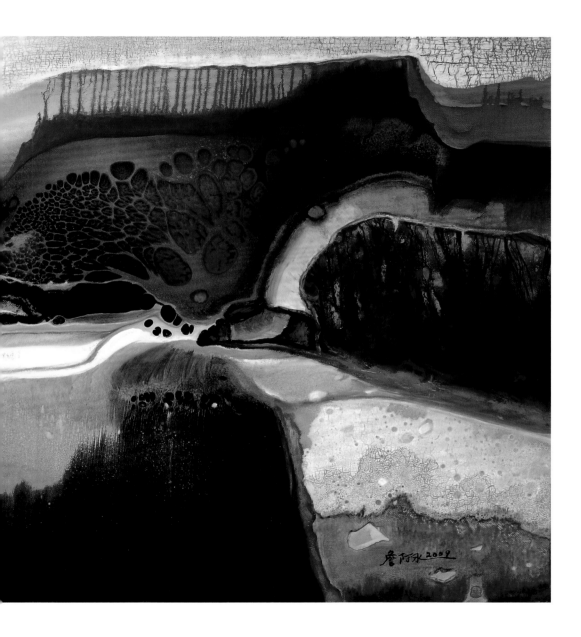

宇宙之秘

2012年
30F　(91cm×72.5cm)

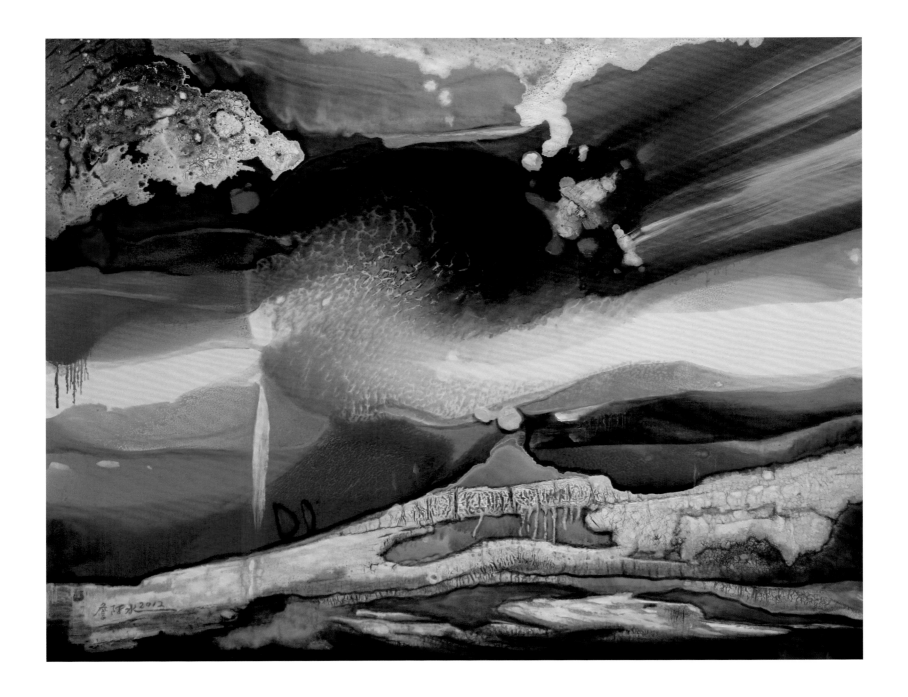

秋晨

2007年
60F （130cm×97cm）

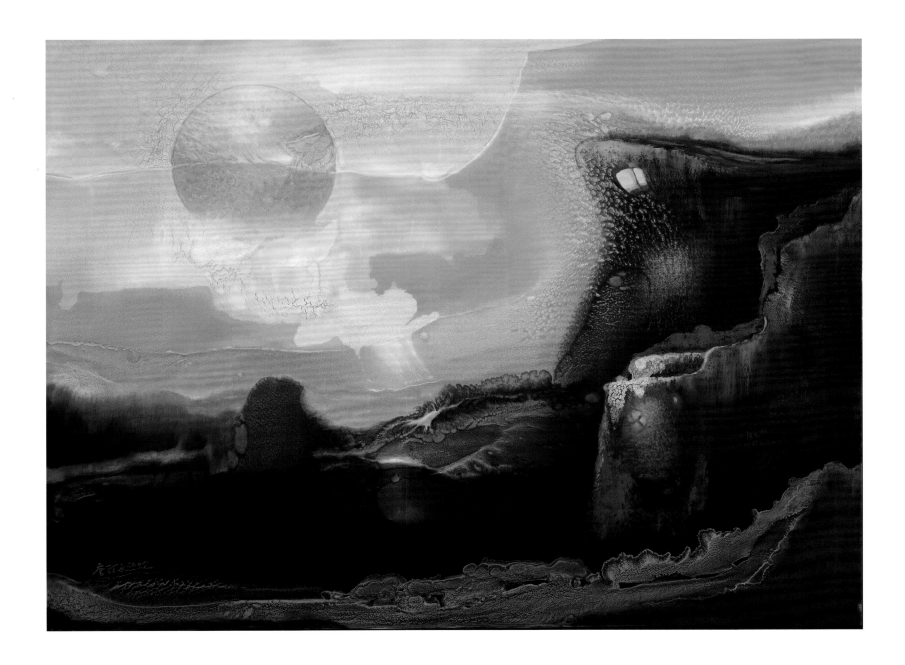

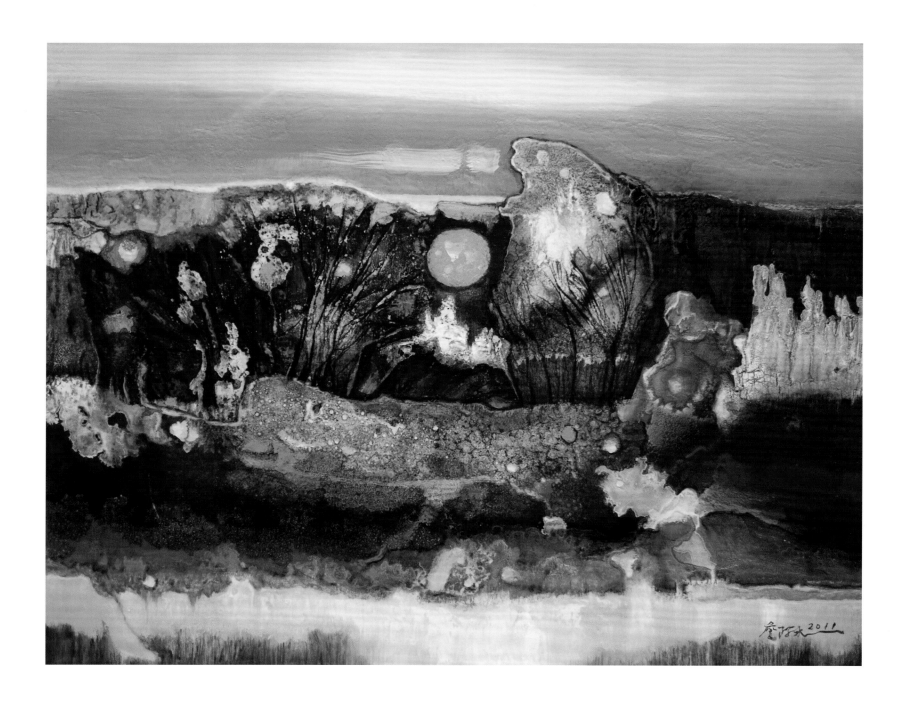

情思之川

2011年
30F　(91cm×72.5cm)

洗塵

2006年
50F （117cm×91cm）

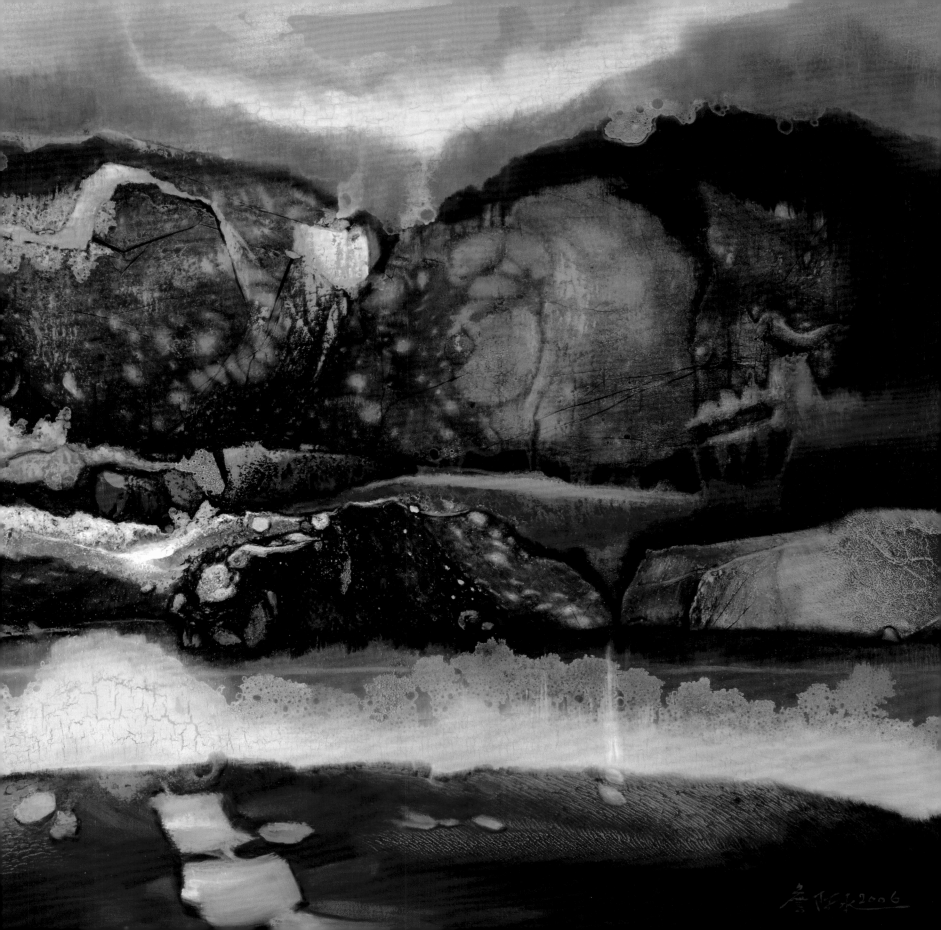

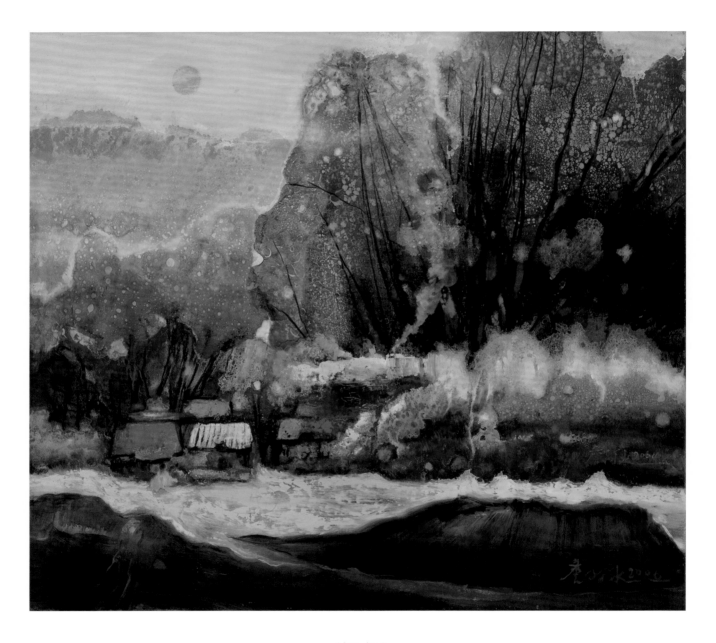

郷居

2006年　15F　（65cm×53cm）

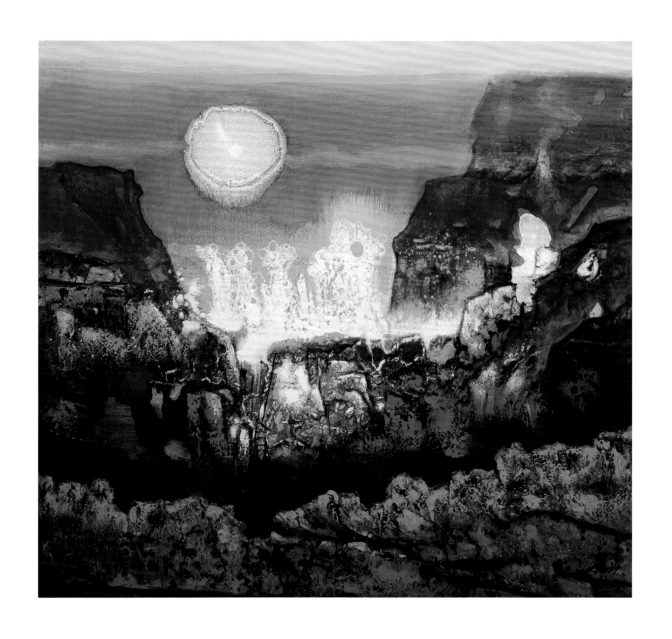

金色山谷

2012年　10F　（53cm×45.5cm）

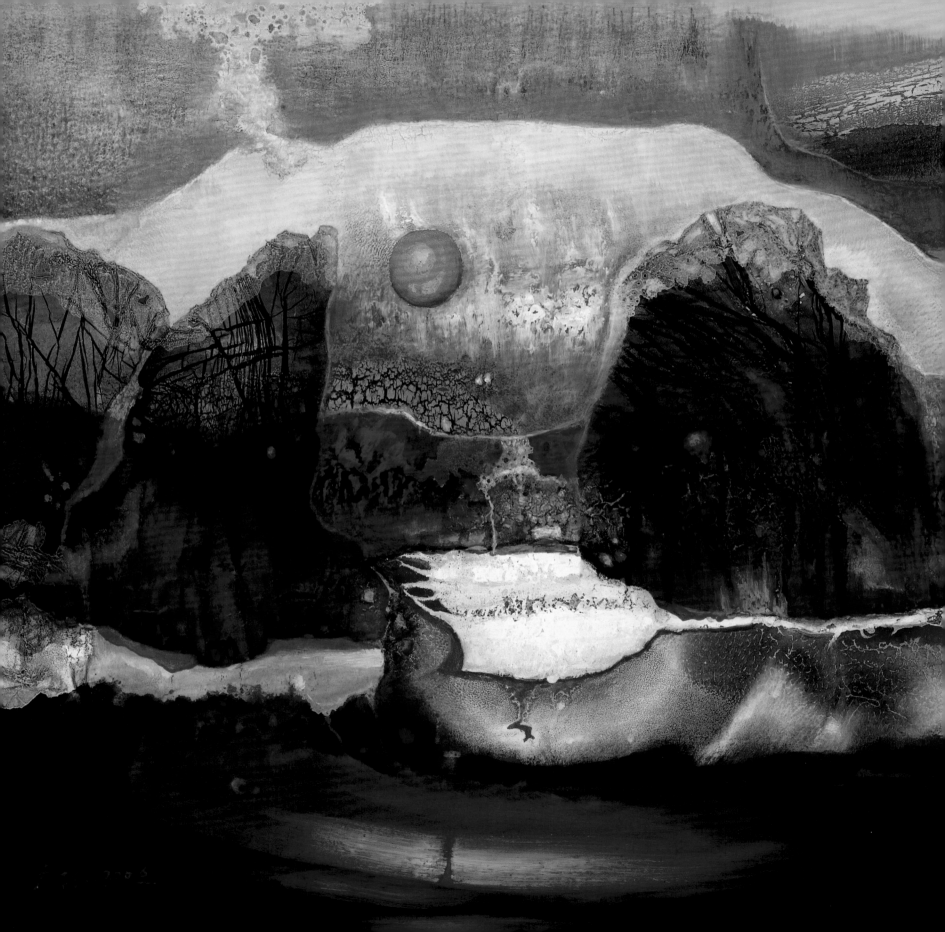

高景

2006年
40F　(100cm×80cm)

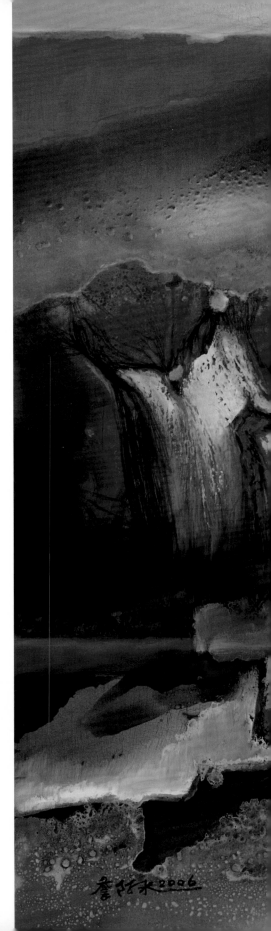

生命之源

2006年
50F （117cm×91cm）

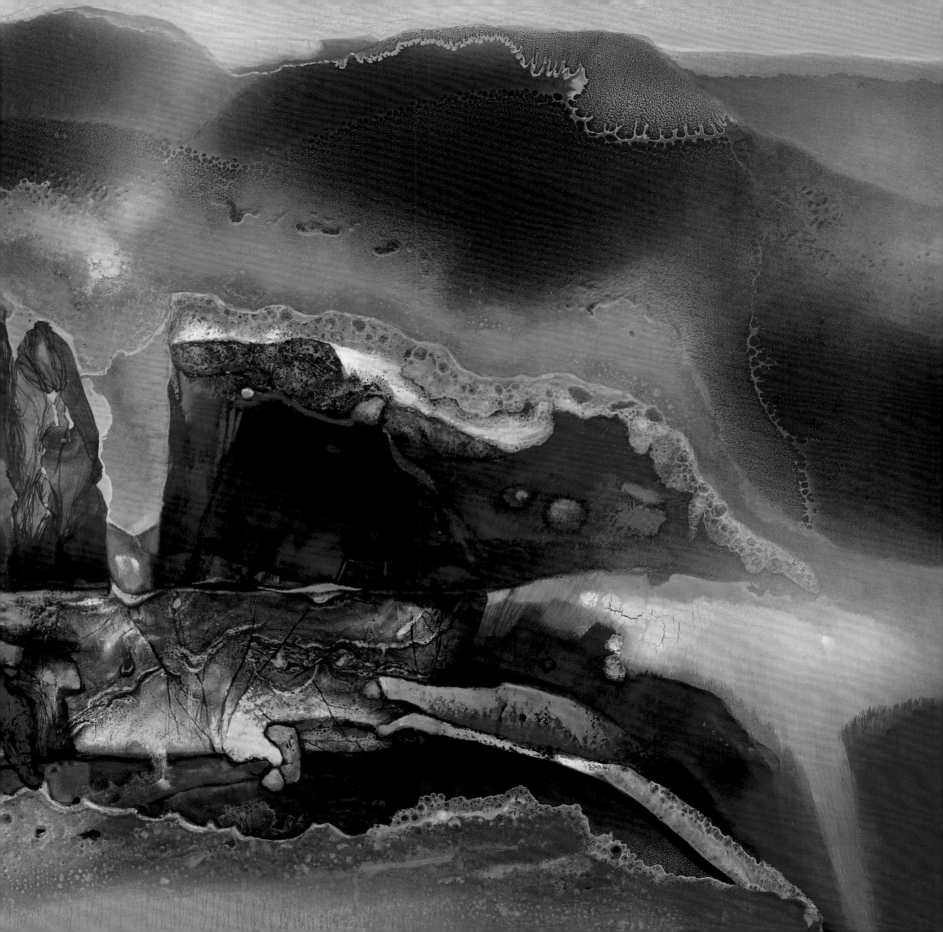

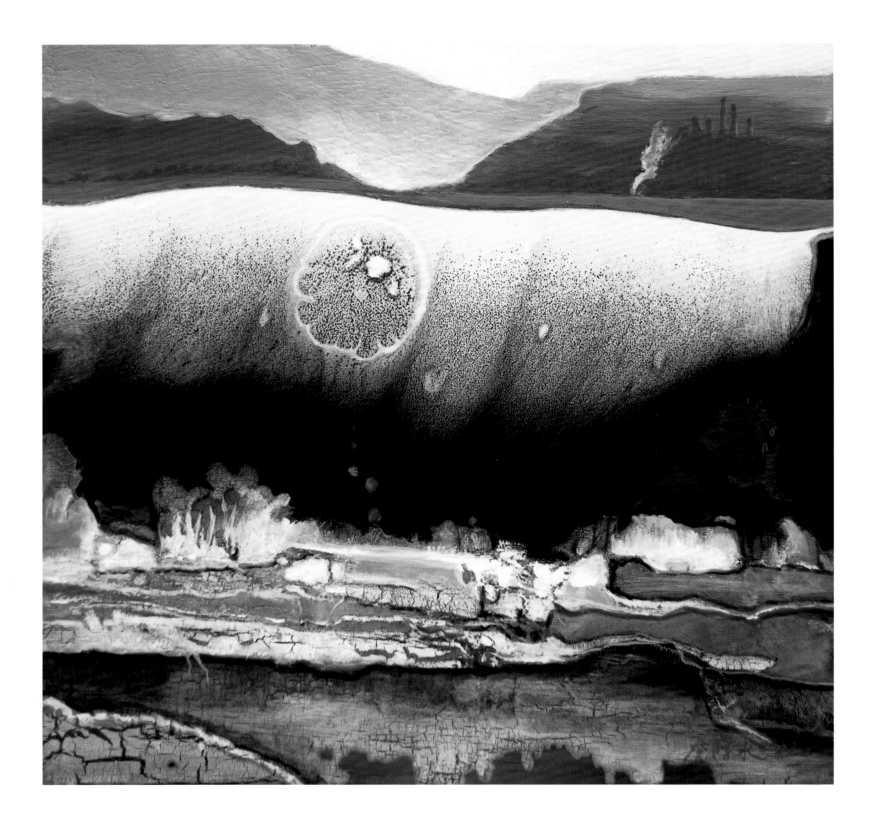

靈隱幽境

2013年
10F （53cm×45.5cm）

黑與白

2009年
20F　(73cm×60.5cm)

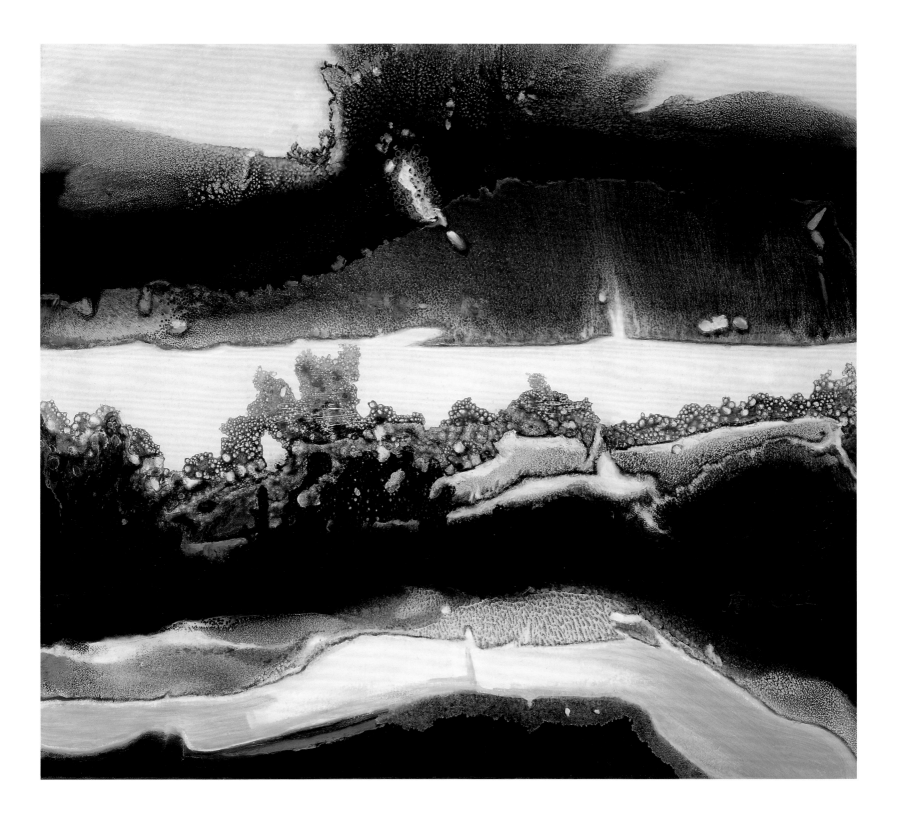

森之冬意

2011年
40F　(100cm×80cm)

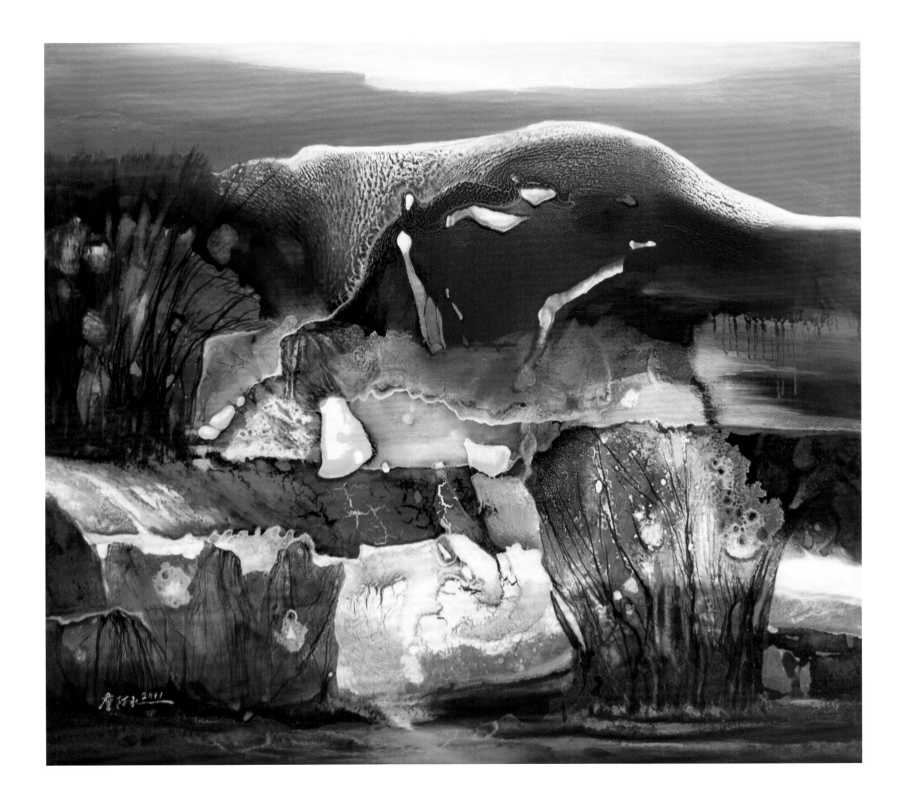

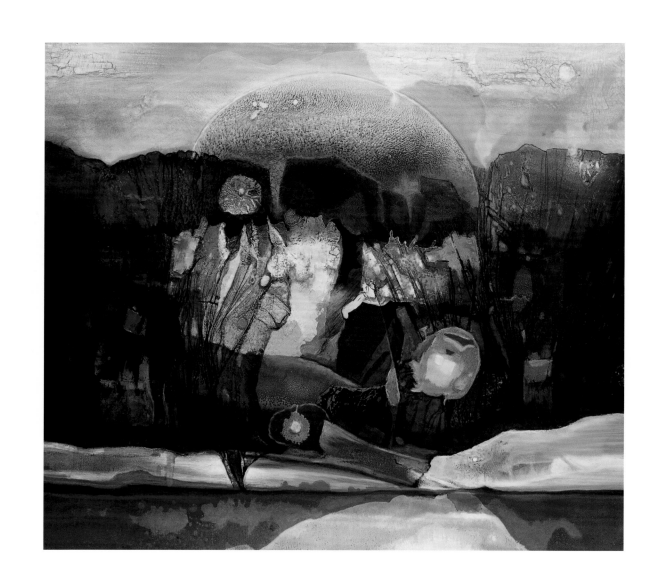

藍色交響曲

2013年　40F　(100cm×80cm)

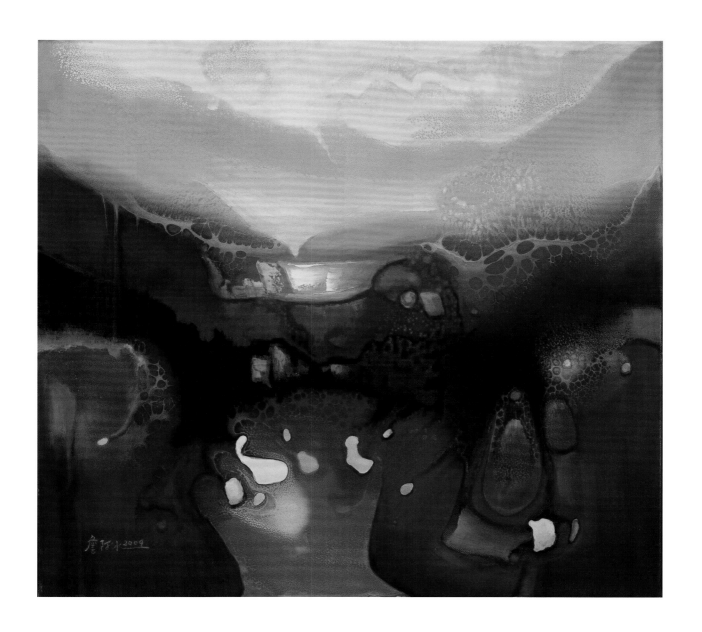

蘊

2009年　20F　(73cm×60.5cm)

夏夜

2006年
40F （100cm×80cm）

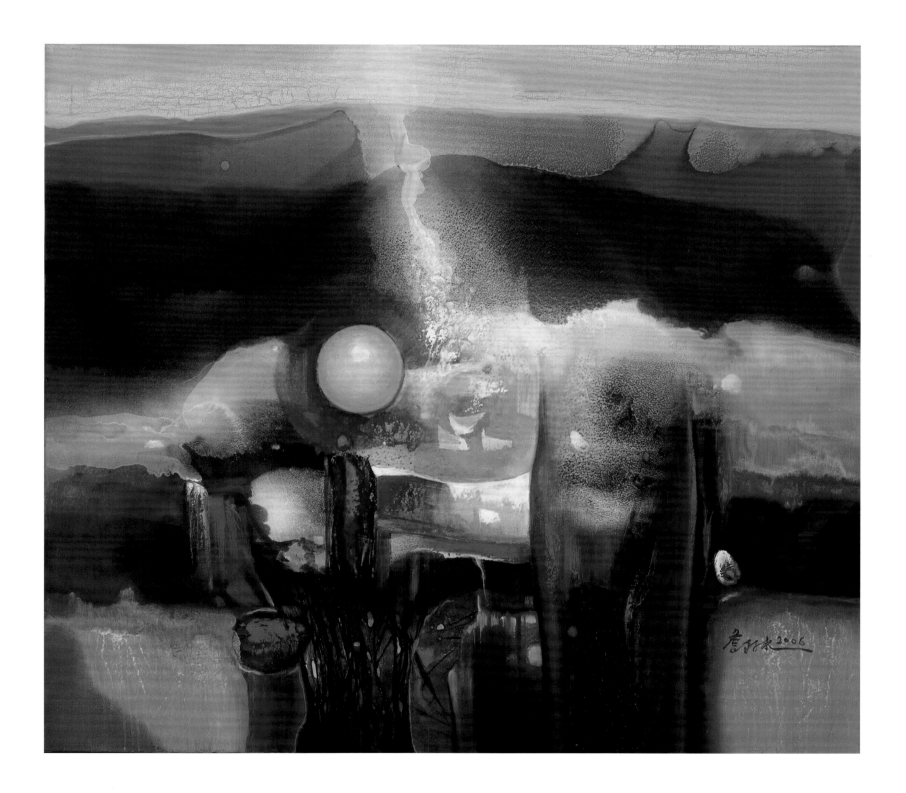

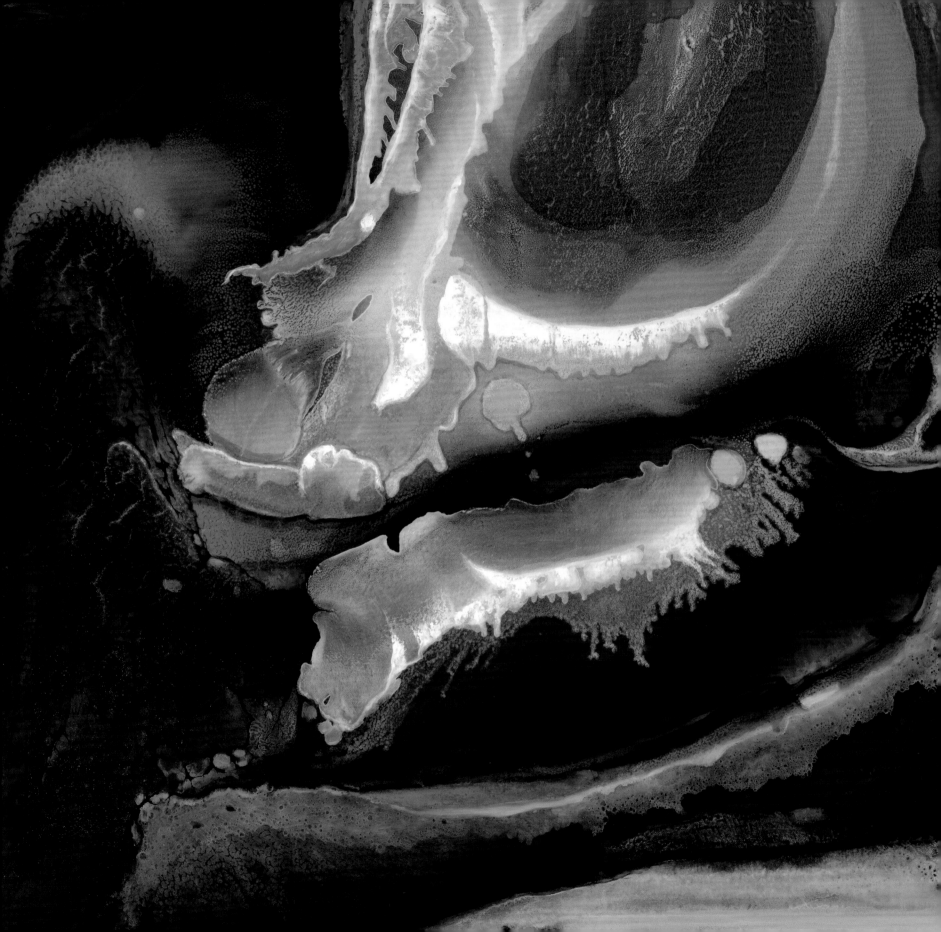

大地萬象

2012年
50F （117cm×91cm）

大地萬千

2015年
50F （117cm×91cm）

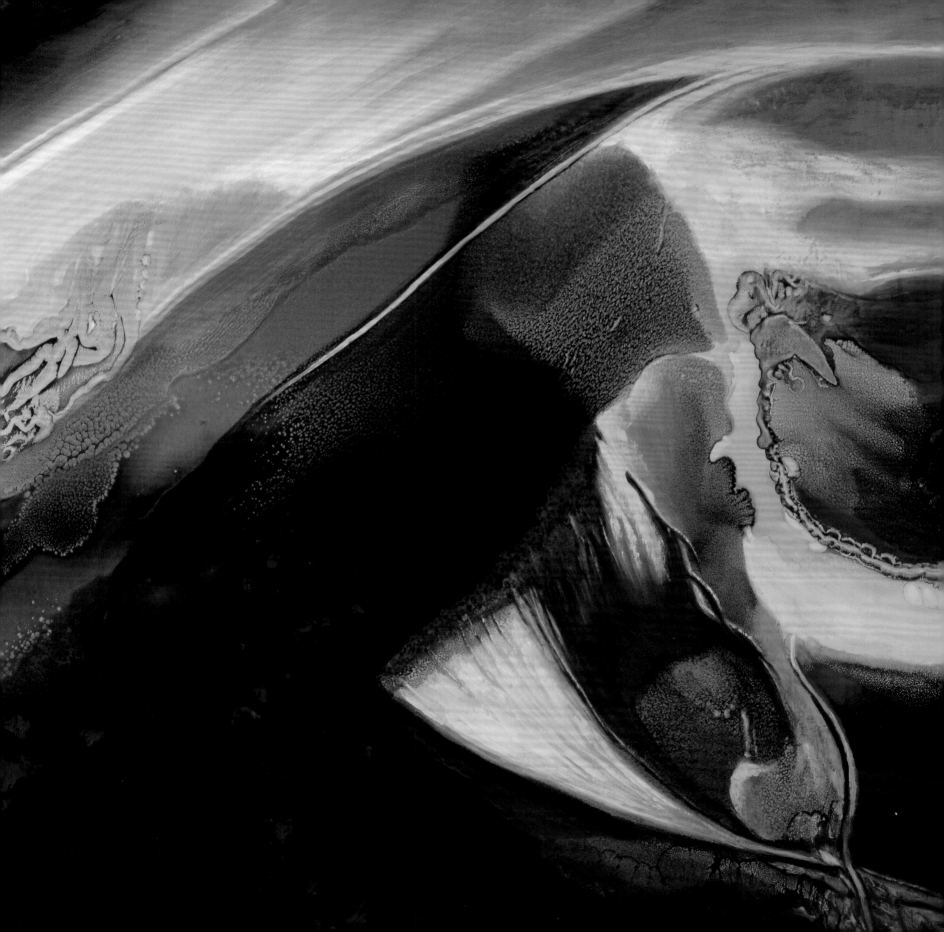

萬馬奔騰

2013年
50F　(117cm×91cm)

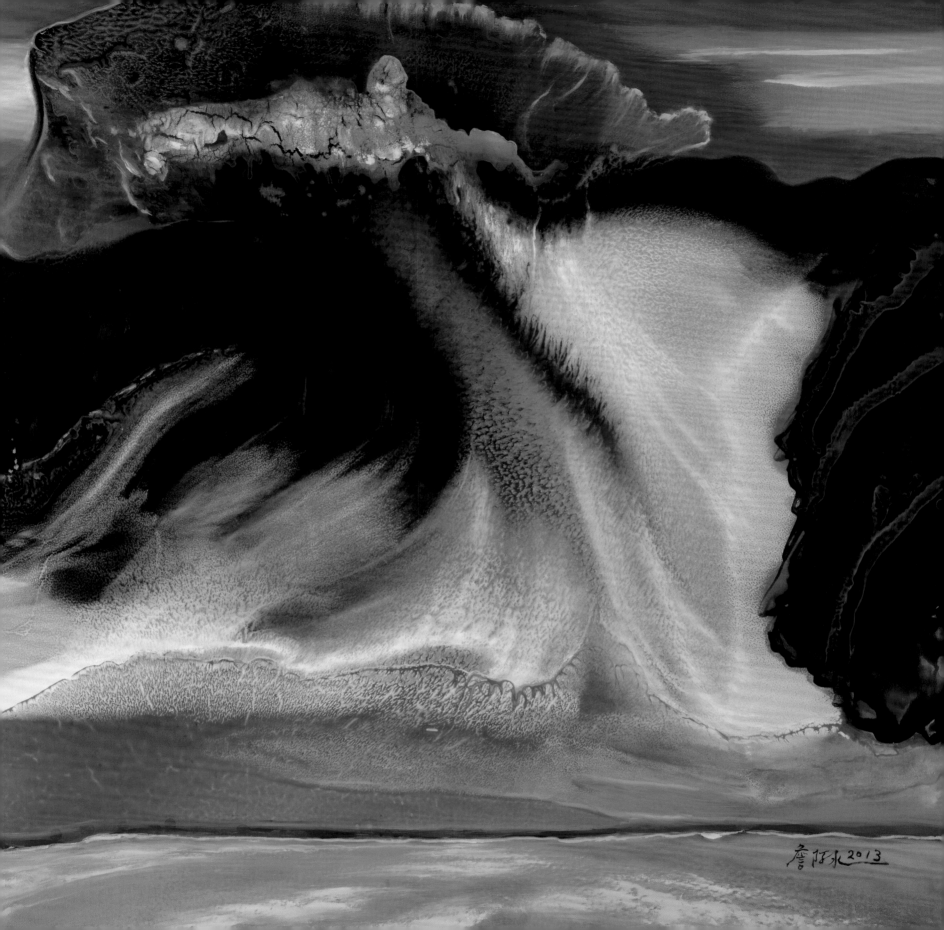

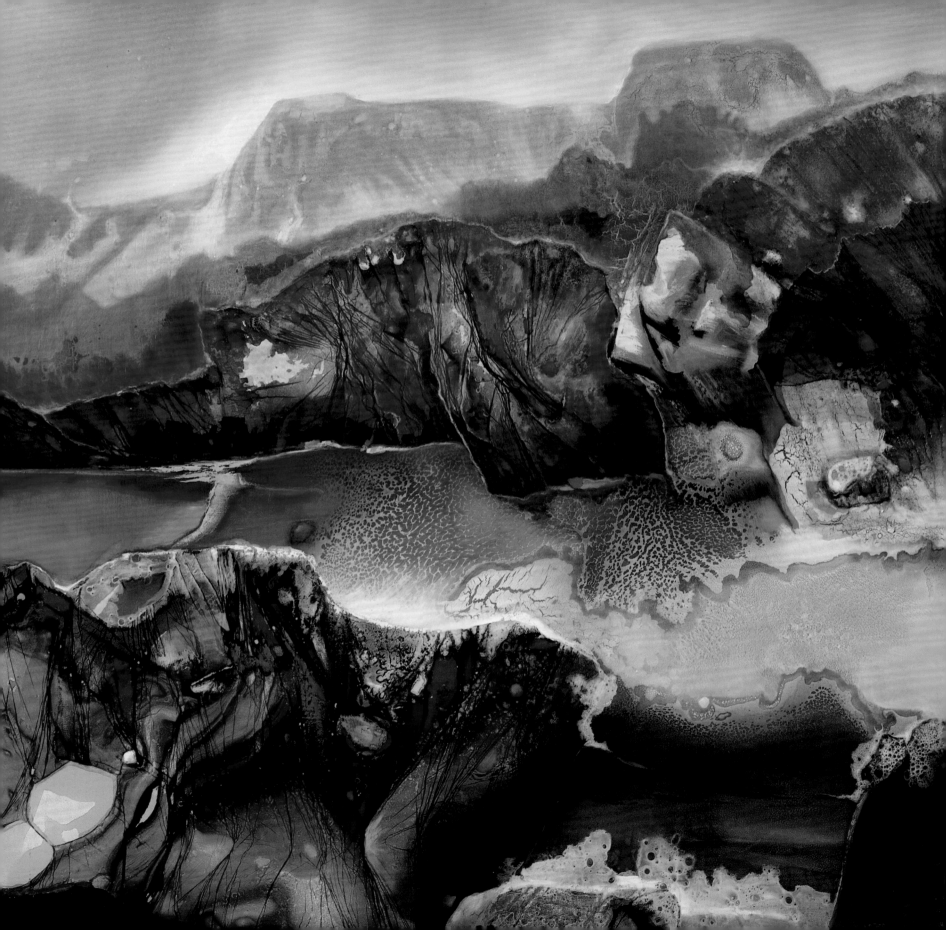

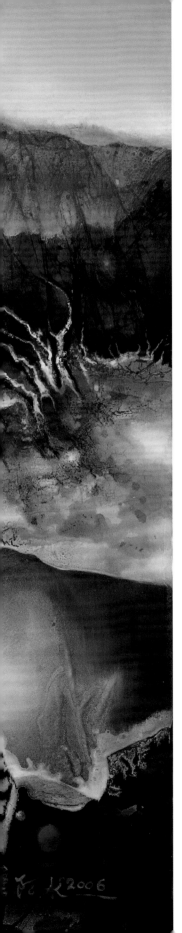

夢中的森林湖畔

2006年
100F （162cm×130cm）

青康藏高原

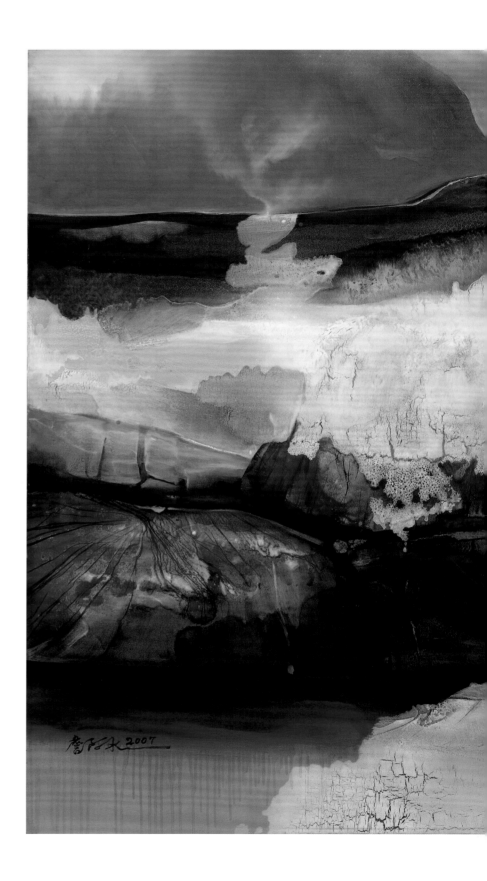

2007年
100F　(162cm×130cm)

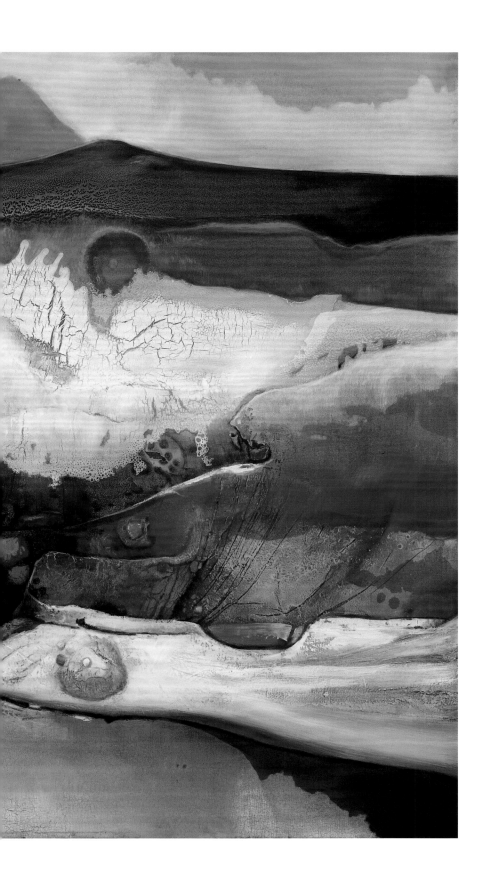

藍色世界

2002年
100F （162cm×130cm）

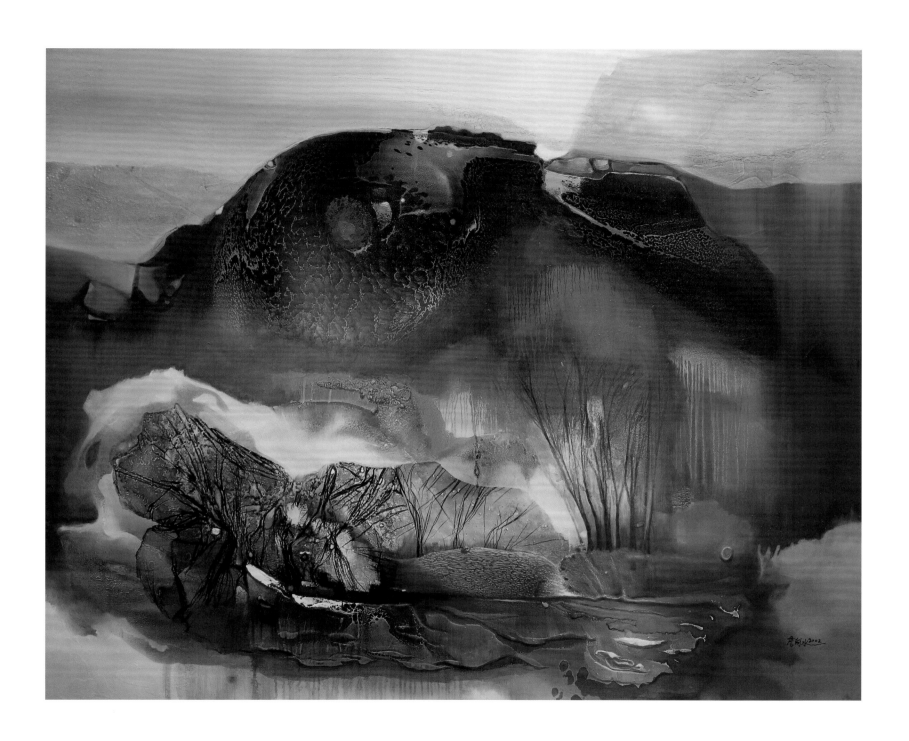

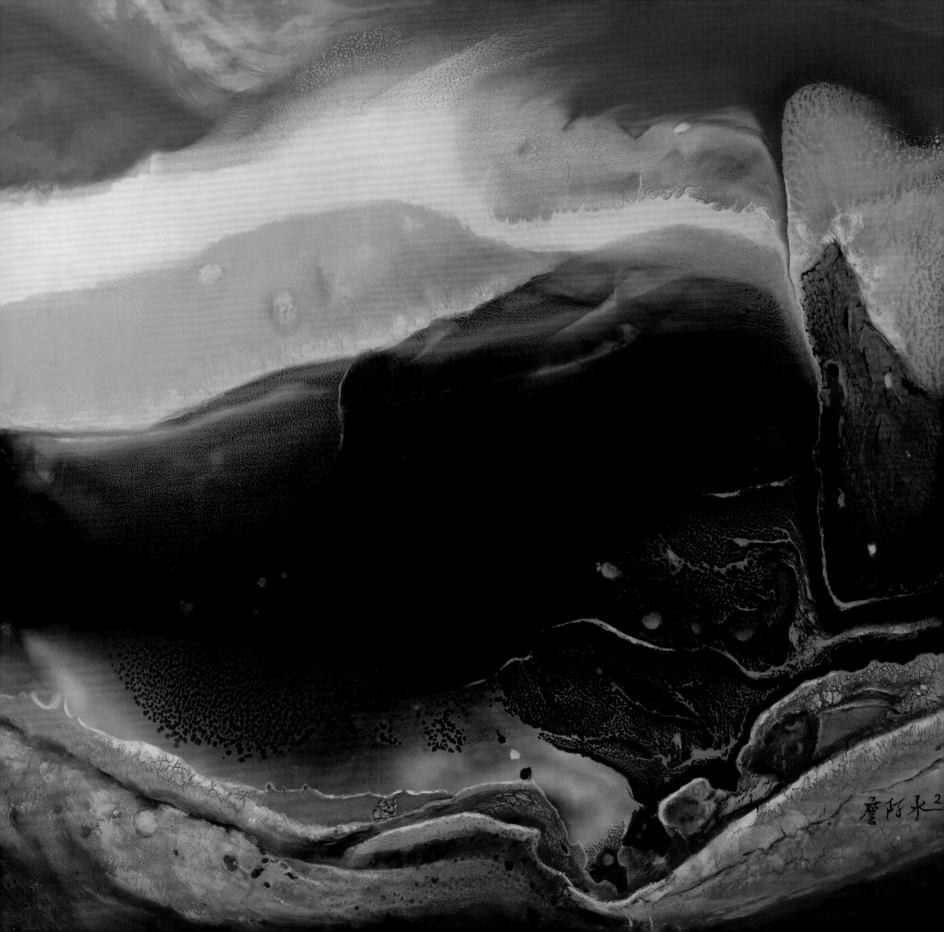

雲起山谷

2015年
50F　(117cm×91cm)

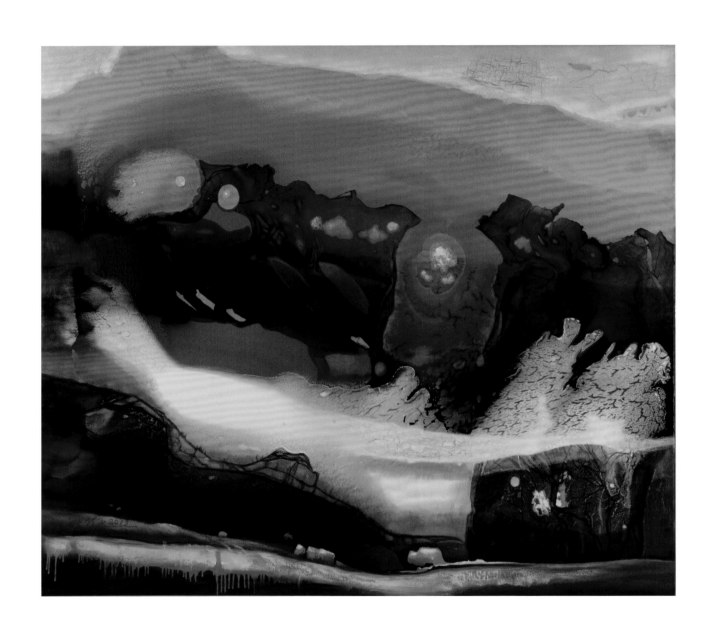

秋染大地

2013年　100F　（162cm×130cm）

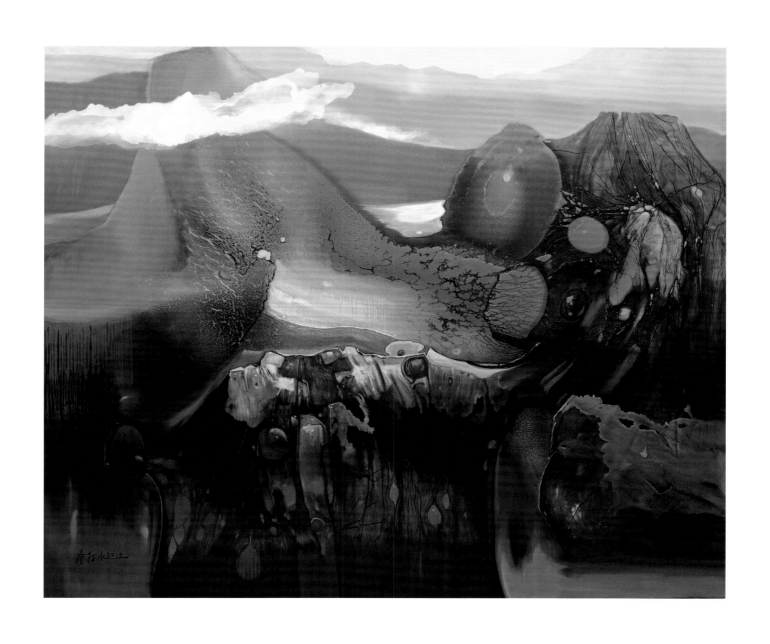

遠山含笑

2015年　200F　(259cm×194cm)

嵐山春晨

2013年
100F　(162cm×130cm)

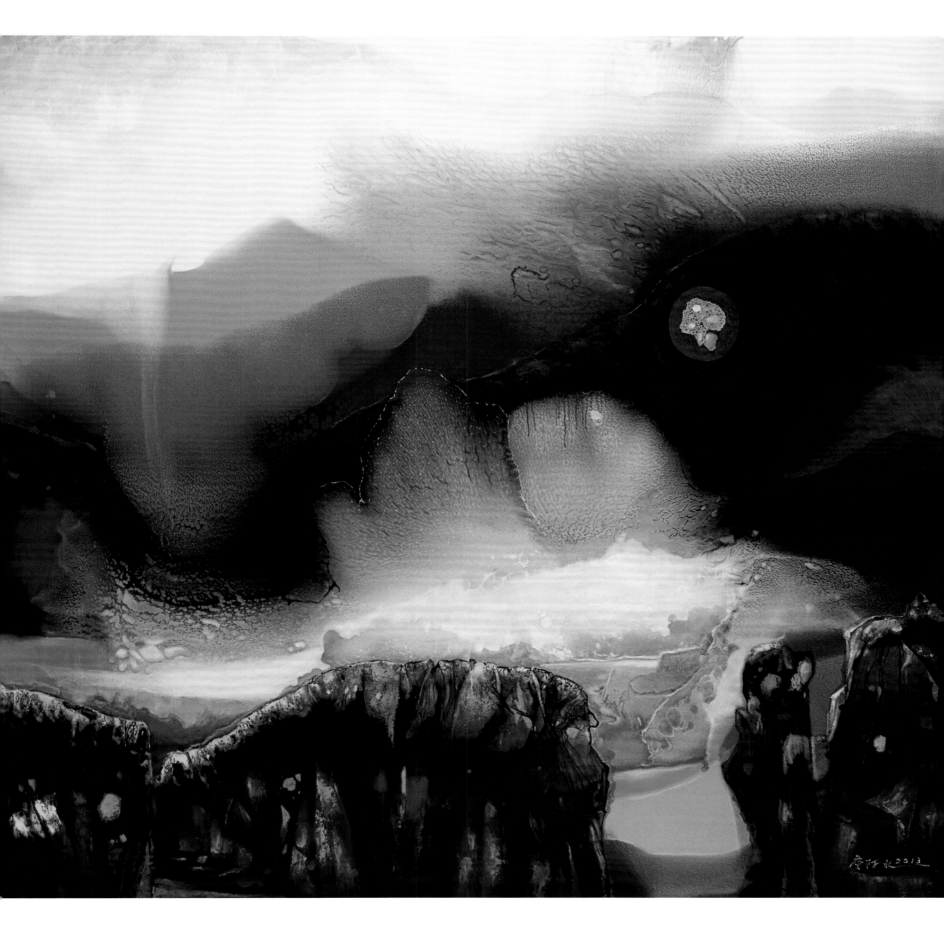

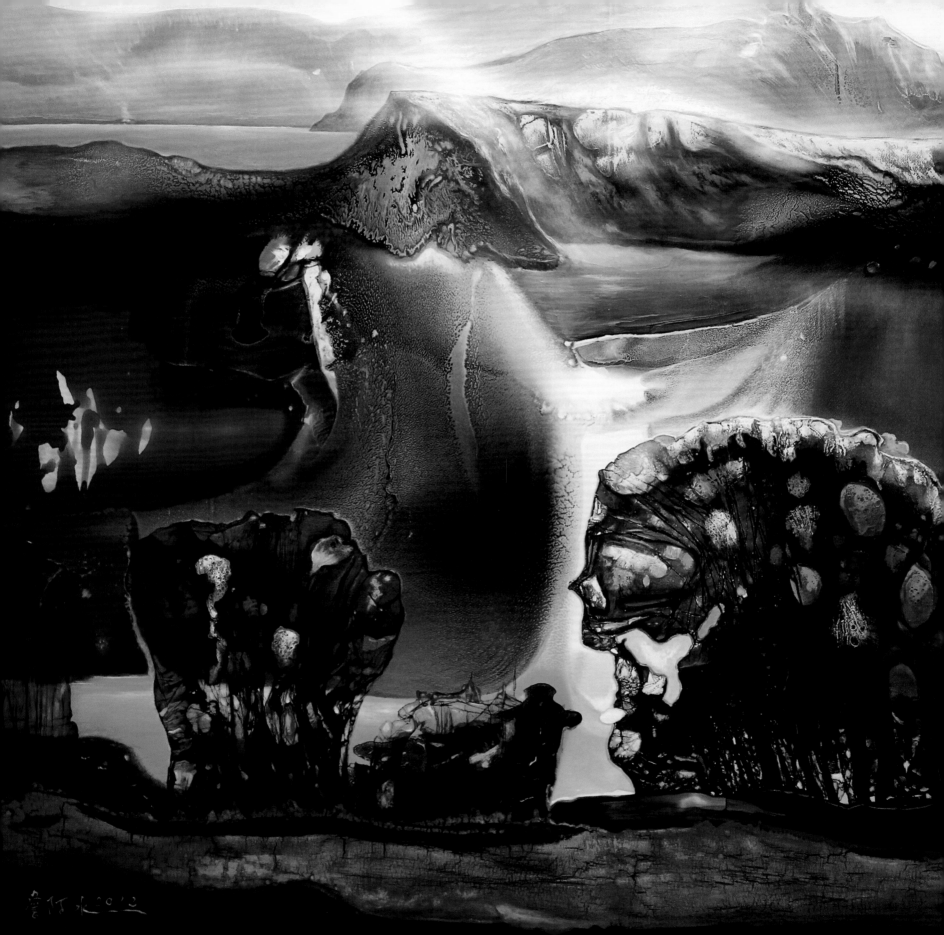

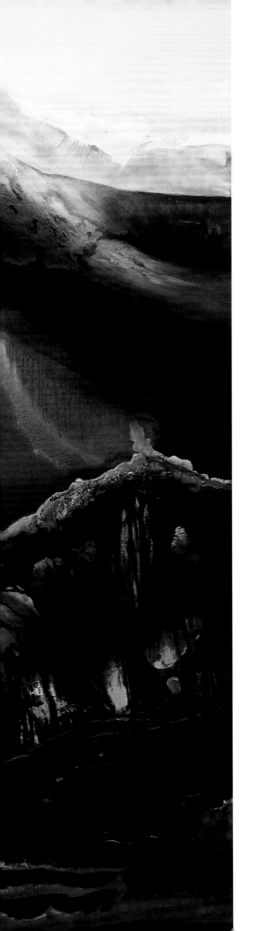

大地春曉

2013年
150P （227cm×162cm）

曙光晚印

2007年
60F （130cm×97cm）

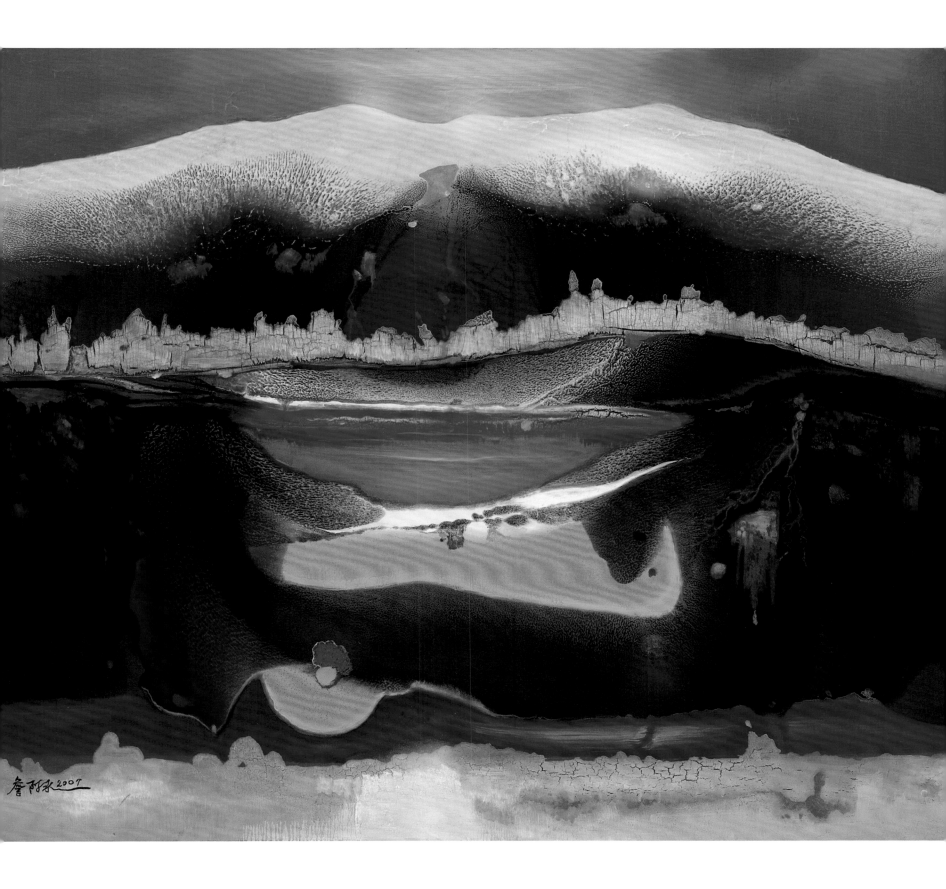

生命之歌

2011年
91cm×76cm

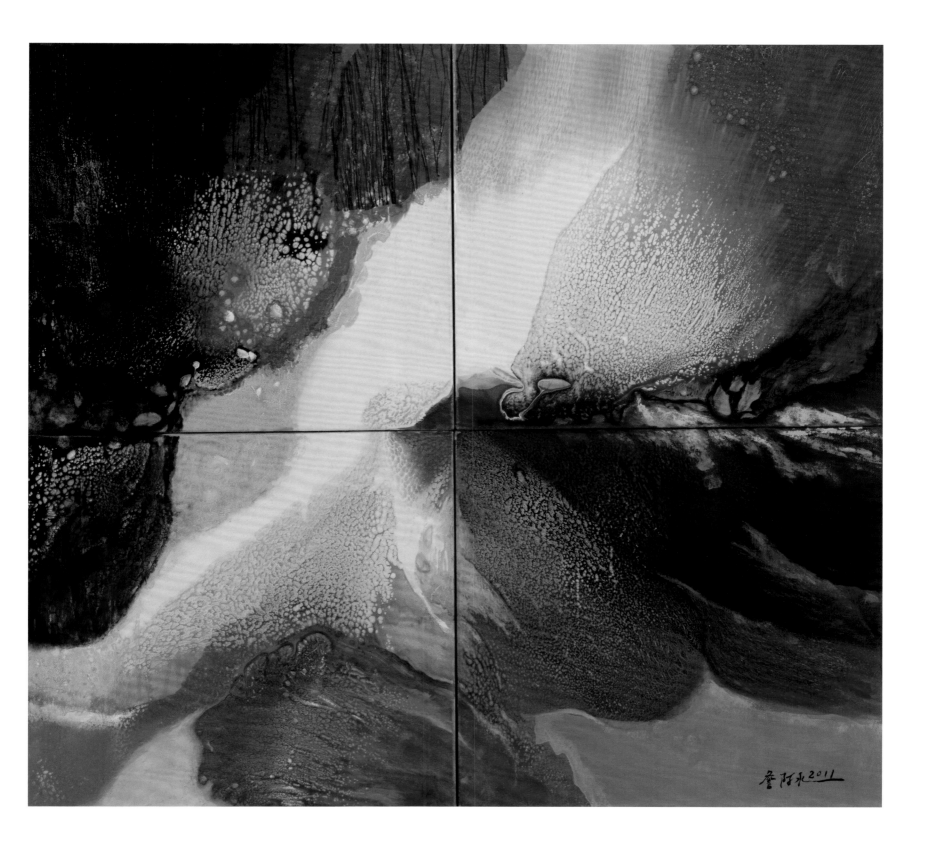

歌頌大地

2015年
50F （117cm×91cm）

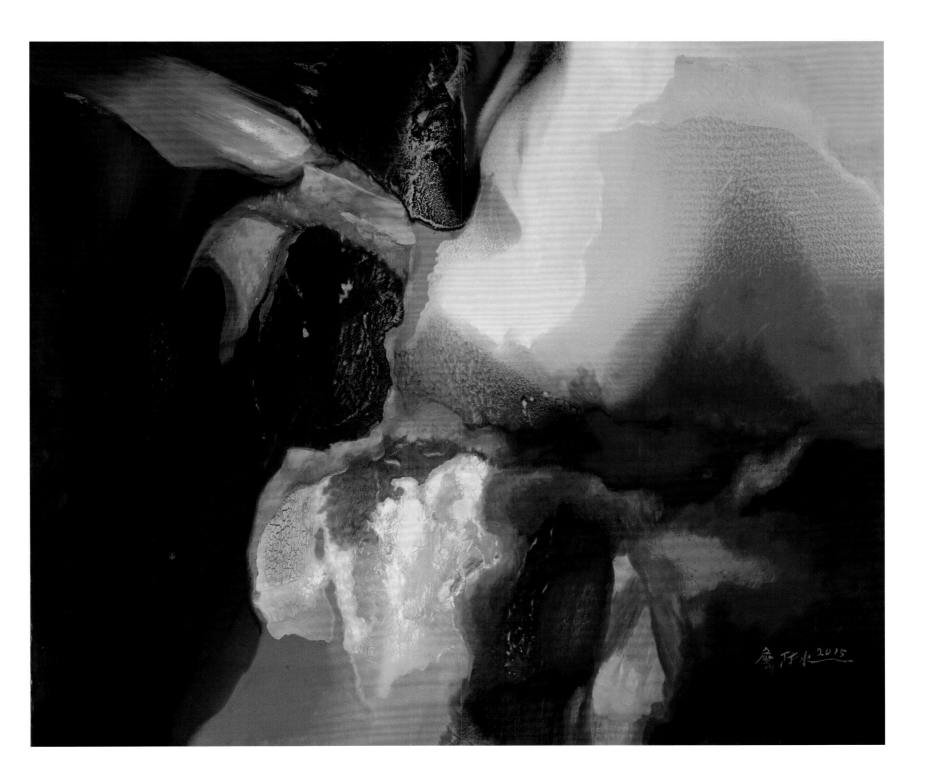

瞻光景藝

2015年
50F （117cm×91cm）

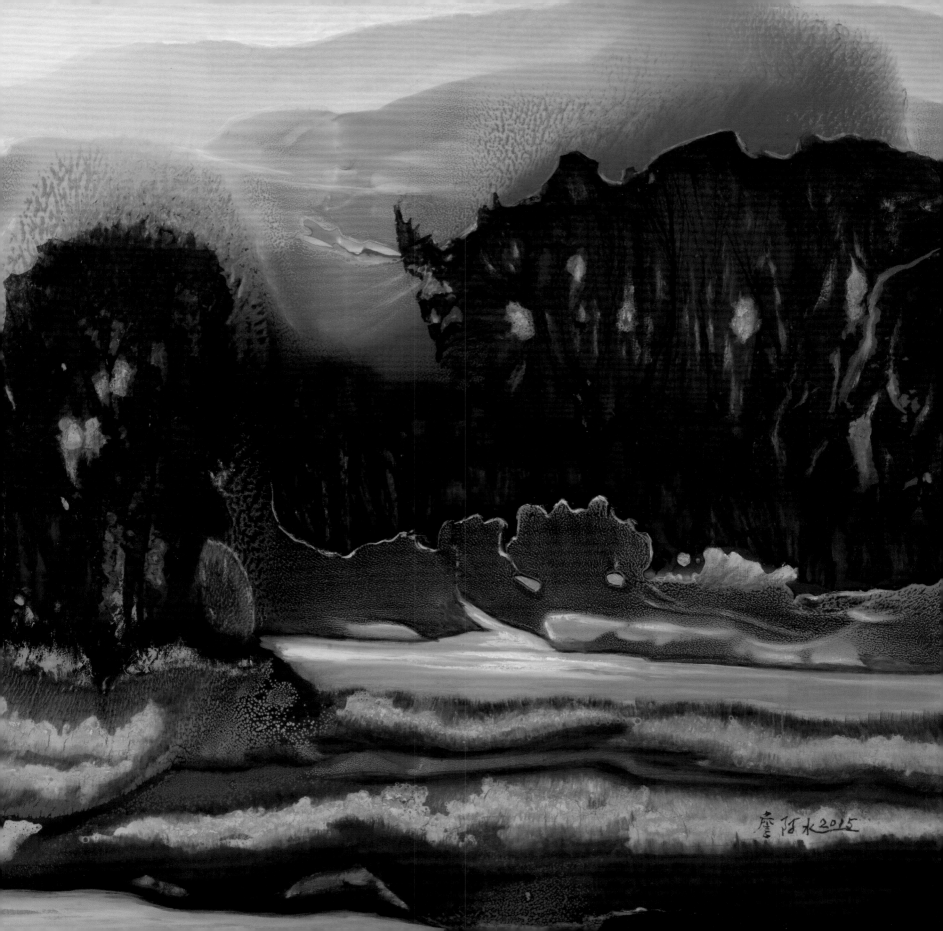

天戀

2014年
50F （91cm×117cm）

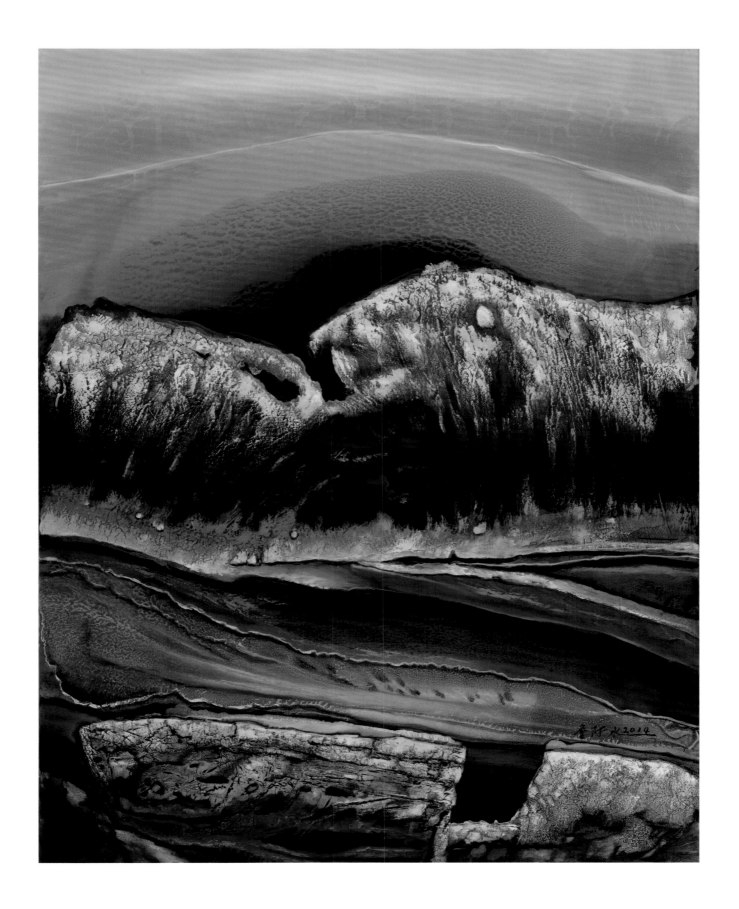

峽江秋色

2015年
50F （117cm×91cm）

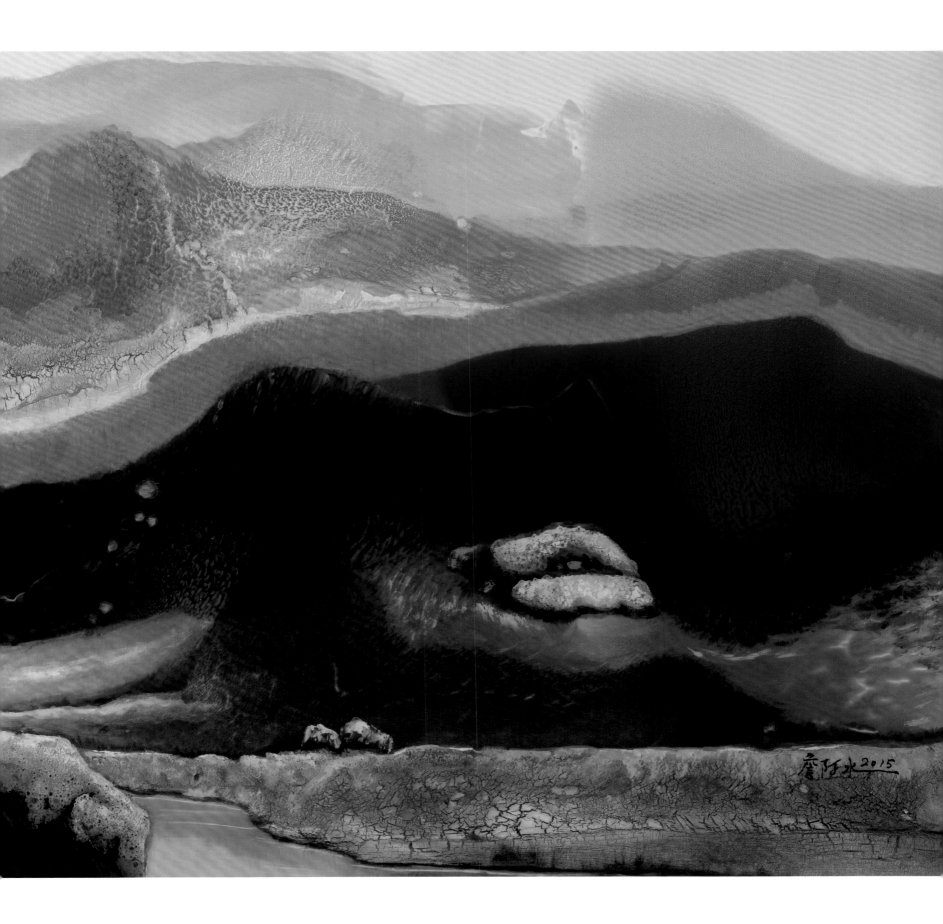

海潮之音

2015年
50F （117cm×91cm）

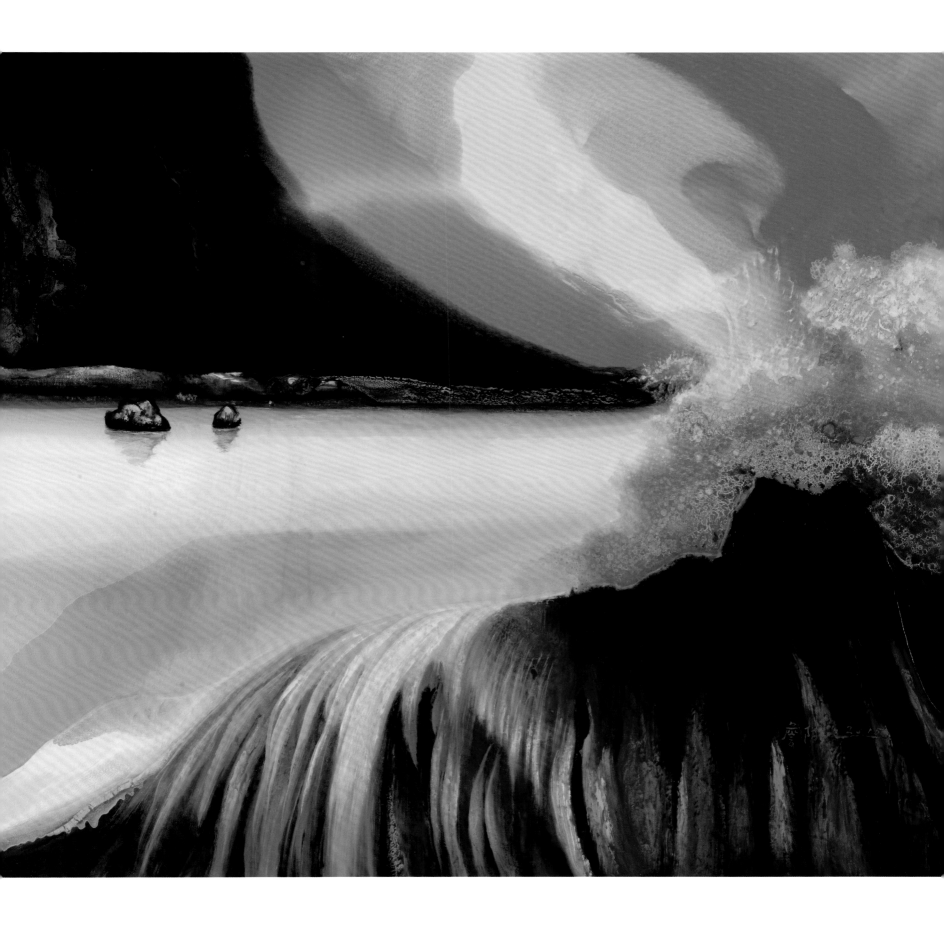

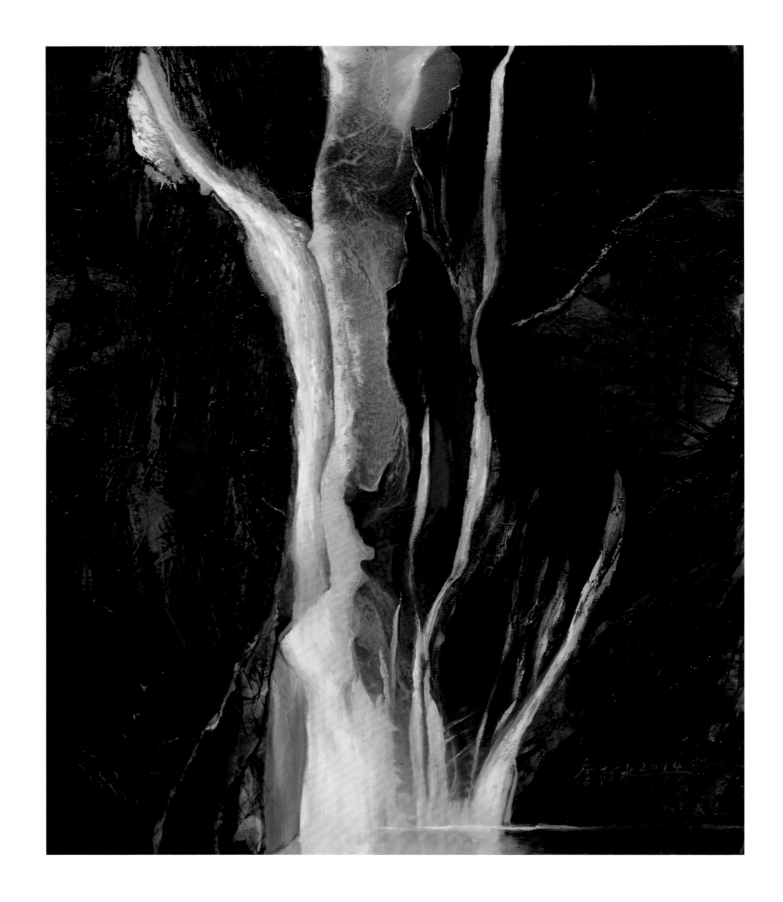

水長悠

2014年
20F　（60.5cm×73cm）

小硫球之鄉

2012年
10F （45.5cm×53cm）

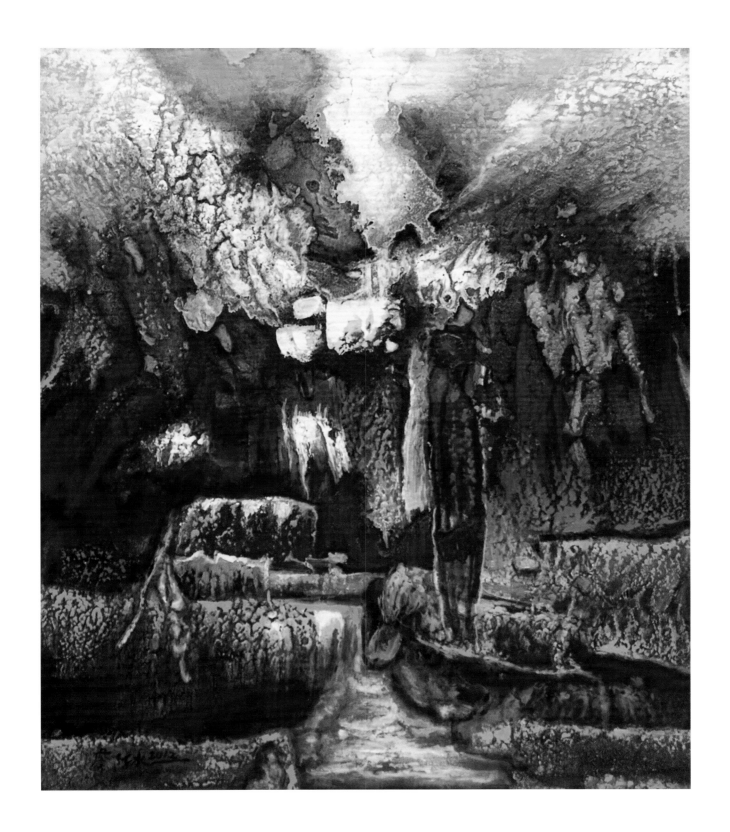

翠谷之秘

2012年
46cm×91cm

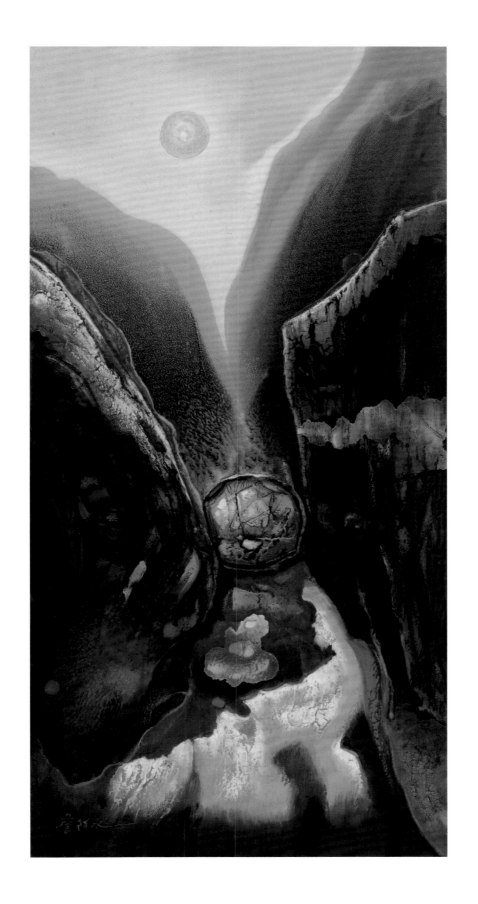

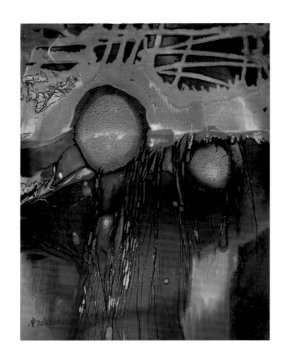

巨 石

2006年　20F (60.5cm×73cm)

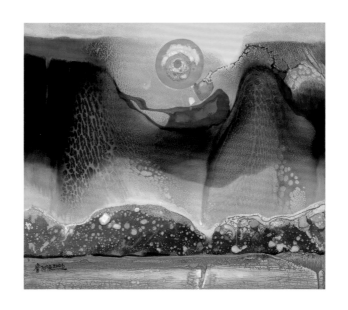

昇 華

2006年　20F (73cm×60.5cm)

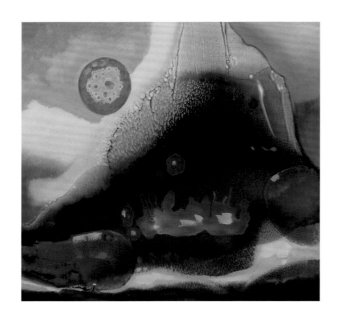

日 出 與 藍 光

2009年　10F (53cm×45.5cm)

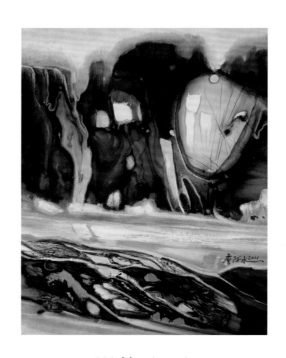

野 柳 (二)

2011年　10F (45.5cm×53cm)

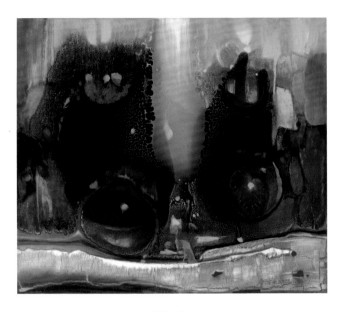

藍 光

2010年 12F (61cm×50cm)

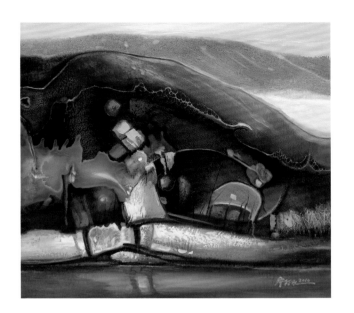

思 情

2010年 15F (65cm×53cm)

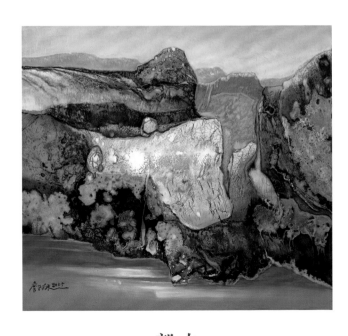

毅 力

2005年 20F (73cm×60.5cm)

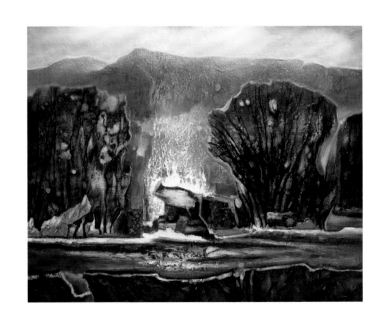

春戀之晨

2006年 15F (53cm×65cm)

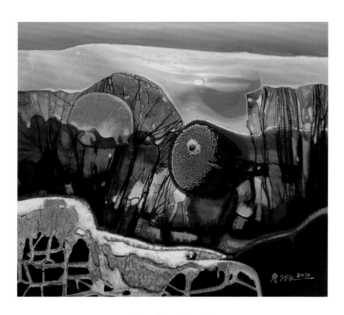

海洋世界

2010年　12F (61cm×50cm)

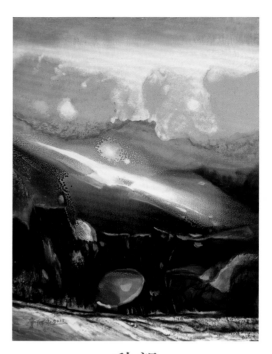

秋韻

2013年　15F (65cm×53cm)

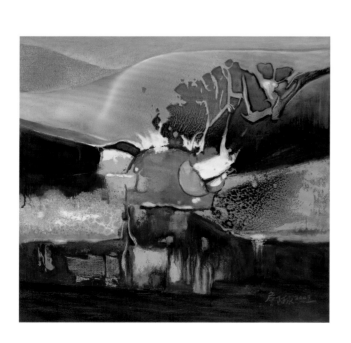

昇華舞影

2009年　15F (65cm×53cm)

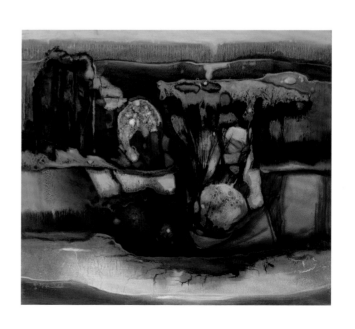

碧湖春色

2008年　12F (61cm×50cm)

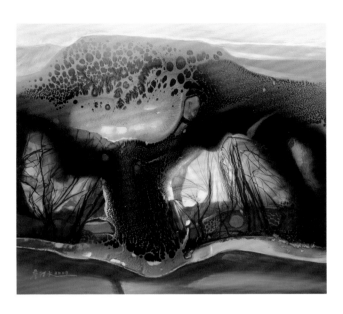

秋望

2008年　15F (65cm×53cm)

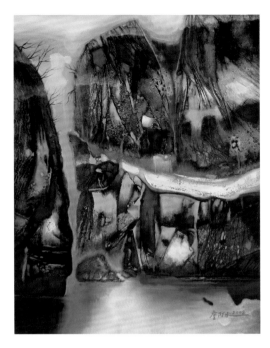

幽谷傳奇

2008年　15F (65cm×53cm)

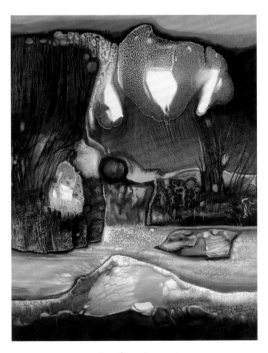

武夷山下

2010年　15F (65cm×53cm)

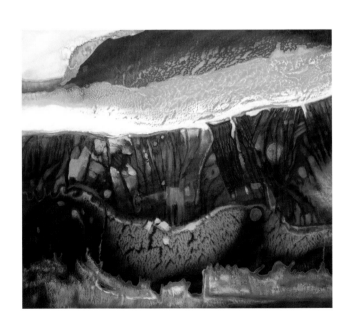

秋之鄉

2012年　15F (65cm×53cm)

抽象大師詹阿水藝術經歷

1946　生於苗栗縣卓蘭鎮

1963　台中縣教育局高中組入選佳作獎

1968　陸軍金像獎競賽入選佳作獎

1969　澎湖聯展／澎湖防衛司令部

1970　世紀畫廊／中部橫貫公路之旅寫生展

1971　台中亞洲畫廊參展

1974　從陳顯棟老師研習現代繪畫雕塑工藝

1983　受邀 國立臺灣博物館（前身：台灣省立博物館）繪製人類生態油畫五幅全台巡迴
　　　展並典藏

1987　赴北京藝術學院交流展

1991　赴日本東京上野美術館／伊勢丹美術館／箱根美術館／研習作品深受日本喜愛
　　　與典藏

1993　台北國際投資展／台北世貿中心

1994　榮獲入編「中國當代藝術界名人錄」「第二卷權威名史冊」

1994　新境文教基金會個展

1994　應邀參加台灣光復五十週年台灣美術大展

1995	台中市立文化中心個展
1995	應邀中華電視台專訪報導
1995	群展藝術中心個展
1995	出版詹阿水油畫選集第一集為心靈的大自然留下空間
1996	受聘上海民族畫院「院士」
1996	陽門藝術中心名家聯展
1996	應邀星雲大師佛光山出版書香套書刊登十餘幅作品
1997	應邀國父紀念館兩岸名家畫展
1997	台中凡石藝術中心個展
1997	第十一屆南瀛美展入選獎中視電視台實況轉播
1997	國立中正紀念堂懷恩藝廊個展
1997	應邀「佛祖心雜誌」53 期專訪刊登六幅作品
1998	豐原名家畫廊個展
1998	國父紀念館「海的傳人澎湖之美」聯展
1998	台北市立萬方醫院萬方畫廊個展
1998	台北世界貿易中心聯誼社藝廊個展作品編印在1998年度行事曆
1999	台中錦江堂藝術中心個展
1999	嘉義市立文化中心個展
1999	應邀朱銘美術館繪製大型壁畫
2000	遍吉齊國際藝術畫廊參展
2000	榮獲第一屆全球華人「藝術獎章」
2000	作品榮獲藝網情深「優質藝術網站獎」

2001　國立中正紀念懷恩藝廊個展

2001　台中錦江堂文教基金會個展

2001　入選第十五屆南瀛美展獎中視電視台實況轉播

2001　應邀中視電視台「巔覆地球」節目專訪

2002　台中市錦江堂文教基金會個展

2002　台中縣立文化中心個展

2002　榮獲中華民國詹姓宗親總會領發畫家 詹阿水「詹姓宗族之光」匾額連續五年大
　　　會手冊採用詹阿水作品作為封面

2002　應邀三立電視台、民視電視台新聞專訪

2002　桃園縣立文化中心個展

2002　台中縣立港區藝術中心個展

2002　台中市立文化中心個展

2002　南投縣政府文化局個展

2002　台南市政府文化局個展

2002　新竹縣文化局個展

2002　彰化縣立中正文化中心個展

2002　台灣電視台藝文畫廊個展

2002　應邀台灣電視台「藝文周報」節目專訪

2002　出版詹阿水精選集第二集形與色的神祕世界

2003　群展人文藝術中心詹阿水、陳澄波、 楊三郎、廖繼春、葉火城聯展

2003　新竹市政府文化局個展

2003　上古藝術畫廊個展

2003　參加環球國際藝術貢獻，榮獲油畫類「金牌獎」

2004　作品榮獲歐洲人士典藏

2004　應邀參加好的藝術在台灣拍賣會

2004　應邀羅芙奧「風動藝術」春季拍賣會

2005　應邀參加春季及秋季好的藝術在台灣拍賣會

2005　參加財團法人淨化社會文教基金會「關心　咱ㄟ下一代」義賣會

2006　應邀參加春季及秋季好的藝術在台灣拍賣會

2006　應邀年代電視台「藝文饗宴」節目專訪

2006　參加台灣、日本、韓國聯合舉辦國際美展，榮獲「銅賞獎」

2007　上古藝術館個展

2008　作品「秋憶」榮獲總統府典藏

2008　國立國父紀念館德明藝廊個展

2008　作品「秋情」榮獲國立國父紀念館典藏

2008　應邀國立國文紀念館 21 期會刊專訪

2008　應邀日本東京『國立新美術館』參展榮獲「特選賞賞獎」駐日經濟文化代表處
　　　讚譽詹阿水畫家「為台灣之光」

2008　應邀客家電視台「藝文名人」專訪

2008　郭東榮、李元亨、詹阿水、尤美玲創作聯展

2009　應邀日本大阪美術館參展

2009　參加八八水災義賣救災活動

2009　應邀參加世貿中心國際藝術交流展及拍賣會

2009　應邀參加春季及秋季好的藝術在台灣拍賣會

2010　郭東榮、詹阿水、鄭乃文、閻振瀛名家油畫聯展

2010　應邀台灣土地銀行總行藝文走廊個展

2010　應邀台灣土地銀行 4 月份「土銀行訊」作品刊登封面及刊登 20 幅作品報導

2010　應邀第一屆台灣「買得起」藝術博覽會

2010　應邀常春雜誌 323 期專題報導

2010　參加台灣國際文化創意產業博覽會「南港展覽館」

2011　應邀台北國際花卉博覽會「爭豔館」我為美而生創作展

2011　四大名家陳永森、郭東榮、詹阿水、王愷，應邀上古藝術當代館開幕聯展

2011　應邀上古藝術當代藝術巨幅油畫創作聯展

2011　應邀第二屆台灣「買得起」藝術博覽會

2011　應邀 TVBS 電視台「來怡客」節目專訪報導

2011　榮獲行政院客委會黃玉振主任委員盛讚詹阿水畫家為「客家之寶」

2012　應邀中央廣播電台「台灣風華」節目專訪報導

2012　應邀客家電視台「名人專訪」報導

2012　應邀非凡電視台「名人專訪」報導

2012　應邀上古藝術，陳永森、郭東榮、詹阿水、王愷特展

2012　應邀客家電視台客家新聞雜誌 269 集專訪報導

2012　應邀參加第三屆台灣「買得起」藝術博覽會

2013　應邀參加上古藝術元宵義拍賣會

2013　榮登詹姓宗親總會「名人錄」被譽為「詹家之光」

2013　應邀參加第四屆台灣「買得起」藝術博覽會及拍賣會

2013　作品「圓仔」捐贈「台北市立動物園」典藏

2013　出版詹阿水創作經典集「形與色」第三集

2014　上古藝術、國際抽象大師詹阿水 50 年創作展

2014　出版詹阿水創作經典集「形與色」第四集、詹阿水創作經典集「形與色」第五集

2014　應邀年代電視台「38 台發現新台灣」節目專題報導

2014　華人新聞界藝術創作聯展、國立國父紀念館

2014　應邀參加第五屆台灣「買得起」藝湧雲起藝術博覽會及拍賣會

2015　應邀參加「第一銀行總行」國際抽象大師詹阿水 70 創作大展

2015　應邀參加第六屆台灣「買得起」藝術博覽會及拍賣會

2015　華人新聞界藝術創作聯展暨兩岸名家邀請展、國立國父紀念館翠溪藝廊

2016　出版詹阿水創作精選 ―「形與色的探索」第六集

Chan A-Shui Chronology

1946 Born in Zhuolan Township, Miaoli County

1963 His artwork was awarded an "Honorable Mention" at the High School Group's Painting Competition, held by the Education Bureau of Taichung County

1968 His artwork was awarded an "Honorable Mention" at the Army Award Competition

1969 Participated in the Penghu Exhibition held by Penghu Defense Command

1970 Participated in the Central Cross-Island Highway Journey Landscape Sketching Exhibition held by the Century Gallery

1971 Participated in an exhibition at the Asia Gallery, Taichung

1974 Studied modern painting and sculpture with Mr. Chen Hsien Tung

1983 Drew 5 oil paintings of Human Ecology for the National Taiwan Museum (The old Taiwan Provincial Museum). His art works were on the Taiwan Tour Exhibition and were collected

1987 Participated in the Exchange Exhibition at the School of Arts in the Peking University

1991 Studied artworks at the Tokyo Ueno Museum / Isetan Museum / Hakone Museum of Art. Some of his artworks were collected by the Japanese Art Appreciation Group

1993 Participated in the Taipei International Investment Show at the Taipei World Trade Center

1994 Chan A-Shui was listed in the "Who's Who of the Chinese Contemporary Art", "The 2nd Volume of The Name List in History "

1994 Solo Exhibition at the Xin Jing Foundation

1994 Participated in the Fiftieth Anniversary of the Retrocession of Taiwan Art Exhibition

1995 Solo Exhibition at the Taichung City Culture Center

1995 Personal Interview and TV reporting by the Chinese Television System (CTS)

1995 Solo exhibition at the Qun -Zhan Art Gallery

1995 Published "Chan A-Shui Painting Album - Leave Room For The Soul Of Nature", 1st edition

1996 Employed by the Chinese Ethnic Painting School in Shanghai as "Academician"

1996 Joint Exhibition at the Yang-Men Art Gallery

1996 Master Hsing Yun Fo Guang Shan published more than 10 prints of Chan A-Shui's artworks in his booklets

1997 Participated in the Cross Strait Celebrity Exhibition at the National Dr. Sun Yat-Sen Memorial Hall

1997 Solo Exhibition at the Fan Shi Art Gallery, Taichung

1997 His artwork was awarded "Judges' Award" at the 11th Nan-Yin Fine Art Exhibition and it was broadcasted by China Television Co (CTV) live

1997 Solo Exhibition at the Huai En Art Gallery, National Chiang Kai-Shek Memorial Hall

1997 Interviewed by the "Buddha's Heart Magazine" and 6 of his artworks were published in the 53rd edition of the magazine

1998 Solo Exhibition at the Feng Yuan Celebrity Art Gallery

1998 Joint Exhibition of "The Successor of the sea, the beauty of Penghu" at the National Dr. Sun Yat-sen Memorial Hall

1998 Solo Exhibition at the Wan Fang Art Gallery, Municipal Wan Fang Hospital, Taipei

1998 Solo Exhibition at the Gallery of the Taipei World Trade Center Club. Artworks were printed on the 1998 calendar

1999 Solo Exhibition at the Jin Chiang Tung Art Gallery, Taichung

1999 Solo Exhibition at the Chiayi City Culture Center

1999 Participated in a large size wall painting at the Juming Museum

2000 Participated in the Exhibition at the Bian Ji Qi International Art Gallery

2000 Awarded a "Medal of Arts" by the First International Chinese Art Award

2000 His artwork was awarded " Quality Art Website Award" by the Yi Wang Qing Shen Website

2001 Solo Exhibition at the Huai En Art Gallery, National Chiang Kai-shek Memorial Hall

2001 Solo Exhibition at the Jin Chiang Tung Art Gallery, Taichung

2001 His artwork was awarded "Judges' Award" at the 15th Nan-Yin Fine Art Exhibition and it was broadcasted by China Television Co (CTV) live

2001 Personal interview for the program "Subversion of the Earth" by the Chinese Television Co (CTV)

2002 Solo Exhibition at the Jin Chiang Tung Art Gallery, Taichung

2002 Solo Exhibition at the Taichung County Culture Center

2002 "The pride of the Chan Family" inscribed on an horizontal board was given by the Family Chan Club Headquarter of R.O.C. His artworks were used as cover pages of the Family Chan Club's booklets for 5 consecutive years.

2002 Personal interview by the News Channel of Sanlih E-Television (SETTV) and FTV

2002 Solo Exhibition at at the Taoyuan County Culture Center

2002 Solo Exhibition at the Taichung County Li Gang District Art Center

2002 Solo Exhibition at at the Taichung City Culture Center

2002 Solo Exhibition at the Cultural Affairs Bureau of Nantou County

2002 Solo Exhibition at the Cultural Affairs Bureau of Tainan City

2002 Solo Exhibition at the Cultural Affairs Bureau of Hsinchu County

2002 Solo Exhibition at the Chiang Kai-shek Cultural Center, Changhua County

2002 Solo Exhibition at the Art Gallery of Taiwan Television Enterprise, Ltd. (TTV)

2002 Personal interview for the program "Art and Culture Weekly" of the Taiwan Television Enterprise, Ltd. (TTV)

2002 Published "Selected Works by Chan A-Shui – A Mysterious World of Shapes and Colors ", 2nd Edition

2003 Chan A-Shui participated in a Joint Exhibition with Chen Cheng-Po, Yang San-Lang, Liao Chi-Chun and Yeh Huo-Cheng at the Qun Zhan Culture Art Center

2003 Solo Exhibition at the Cultural Affairs Bureau of Hsinchu City

2003 Solo Exhibition at the Sogo Art Gallery

2003 Participated in the Global International Art contribution. His painting received a "Gold Medal" in the oil-painting category

2004 His painting was collected by a French medical doctor in Belgium

2004 Participated in the Fine Arts in Taiwan Auction 2004

2004 Participated in the Ravenel Spring Auction 2004

2005 Participated in the Fine Arts in Taiwan Spring and Autumn Auctions 2005

2005 Participated in the auction for charity of "Let's care for our next generation" held by the Jinghua Society Cultural Foundation

2006 Participated in the Fine Arts in Taiwan Spring and Autumn Auctions 2006

2006 Personal interview by "Art and Culture Feast" for EraTV

2006 Participated in the International Art Exhibition jointly held by Taiwan, Japan and South Korea. Won the "Bronze Medal Award"

2007	Solo Exhibition at the Sogo Art Gallery
2008	His artwork "The memory in Autumn" was collected by the office of the President
2008	Solo Exhibition at the Deming Art Gallery at the National Dr. Sun Yat-sen Memorial Hall
2008	His artwork "Autumn Love" was collected by the National Dr. Sun Yat-sen Memorial Hall
2008	Personal interview for the magazine of the National Dr. Sun Yat-sen Memorial Hall. It was published in the 21st edition of the magazine
2008	Participated in the "Art Mirai International Art Exhibition" at The National Art Center, Tokyo, Japan. His painting received the "Outstanding Art Prize". The Taipei Economic and Cultural Representative Office in Japan praised Chan A-Shui as "the pride of Taiwan"
2008	Personal interview by Hakka TV for the program "Celebrity in the Art Society"
2008	Chan A-Shui participated in a Joint Exhibition of Creative Artworks with artists Kuo Tong-Jong, Lee Yung-Han and Yu Mei-Lin
2009	Participated in an exhibition at the National Museum of Art, Osaka, Japan
2009	Participated in the 88 Flood Disaster Relief Activity
2009	Participated in the Exchange Exhibition and Auction of the International Art at the World Trade Center, Taipei
2009	Participated in the Fine Arts in Taiwan Spring and Autumn Auctions 2009
2010	Chan A-Shui participated in a Joint Exhibition of Oil Paintings with artists Kuo Tong-Jong, Cheng Nai-Wen and Yen Chen-Ying
2010	Solo Exhibition at the Art Gallery Corridor in the headquarter of the Land Bank of Taiwan

2010 20 artworks were mentioned in the April edition of the " Branch News of the Land Bank of Taiwan". His painting was used to illustrate the cover page

2010 Participated in the 1st Affordable Art Fair Taiwan (AAF, Taiwan)

2010 Personal interview and report by the 323rd edition of the Evergreen Magazine

2010 Participated in the Taiwan International Cultural and Creative Industry Expo 2010, Taipei World Trade Center, Nangang Exhibition Hall

2011 Participated in the exhibition "I Was Born For The Beauty" at the Taipei International Flora Exposition, Expo Hall

2011 Chan A-Shui participated in a Joint Exhibition with artists Chen Yong-sen, Kuo Tong-Jong and Wang Kai for the opening of the Contemporary Hall of the Sogo Art Gallery

2011 Participated in the Joint Exhibition of Contemporary Art of Large Scale Oil Painting at the Sogo Art Gallery

2011 Participated in the 2nd Affordable Art Fair Taiwan (AAF, Taiwan)

2011 Personal Interview for the program " Lai-Yi Ke Hakka" of TVBS TV

2011 Chairperson Huang Yu-Zhen of the Hakka Affairs Council at the Executive Yuan praised Chan A-Shui as "The treasure of Hakka people"

2012 Personal Interview for the program "The Glory of Taiwan" of Radio Taiwan International

2012 Personal interview for the program "Talk with Celebrity" of Hakka TV

2012 Personal interview for the program "Talk with Celebrity" of Unique Satellite TV

2012 Chan A-Shui participated in a Joint Exhibition with artists Chen Yong-sen, Kuo Tong-Jong and Wang Kai at the Sogo Art Gallery

2012 Personal interview by the Hakka News Magazine of the Hakka TV. Published in the 269th edition of the magazine

2012 Participated in the 3rd Affordable Art Fair Taiwan (AAF, Taiwan)

2013 Participated in the Auction for Charity for the Lantern Festival at the Sogo Art Gallery

2013 Chan A-Shui was honorably listed in the "Who's who" of the Family Chan Club Headquarter of R.O.C. and was praised as "The pride of the Chan Family"

2013 Participated in the 4th Affordable Art Fair and Auction Taiwan (AAF, Taiwan)

2013 The painting "Baby Giant Panda" was donated to the Taipei Zoo

2013 Published "Selected Works by Chan A-Shui – A Mysterious World of Shapes and Colors ", 3rd Edition

2014 Solo Exhibition at Sogo Art Gallery, Chan A-Shui's abstract masterpieces for 50 years

2014 Published "Selected Works by Chan A-Shui – A Mysterious World of Shapes and Colors ", 4th Edition and 5th Edition

2014 Personal interview for the program "TV38 Discover new Taiwan" of EraTV

2014 Participated in the Chinese Press Art Joint Exhibition at the National Dr. Sun Yat-sen Memorial Hall

2014 Participated in the 5th Affordable Art Fair and Auction Taiwan (AAF, Taiwan)

2015 Solo Exhibition at the First Commercial Bank Headquarter

2015 Participated in the 6th Affordable Art Fair and Auction Taiwan (AAF, Taiwan)

2015 Participated in the Cross Strait Chinese Artist and Chinese Press Art Joint Exhibition at the Tswei-xi Gallery of National Dr. Sun Yat-sen Memorial Hall

2016 Published "The Selected Artworks by Chan A-Shui – The Exploration of Shapes and Colors", 6th Edition

詹阿水創作精選

發 行 人：詹曉霖
作 者：詹阿水
策劃編輯：詹曉霖
執行編輯：鄭敬儒 、 劉躍
英文翻譯：詹曉霖 、 尉可瑟
美術設計：劉悅德
顧 問：尉可瑟 、 鄭敬儒 、 劉躍
出 版 者：靜慮藝術
連絡地址：台北市信義區 110 吳興街 269 巷一弄 3 號 4 樓
連絡電話 (台灣)：+886 2 27222094 / +886 922242529 / +886 926493412
連絡電話 (比利時)： +32 478374361
E - m a i l：ashui.chan@gmail.com / carolchan1975@gmail.com
發行日期：2016 年 2 月
定 價：新臺幣 1500 元

ISBN 978-986-93053-0-3

出版單位：靜慮藝術股份有限公司
形與色的探索: 詹阿水創作精選 / 詹阿水作
(精裝) NTS : 1500

9 789869 305303

The Selected Artworks by Chan A-Shui

Issuer : CHAN, Hsiao-Lin
Author：CHAN, A-Shui
Planning editor： CHAN, Hsiao-Lin
Executive editor：CHENG, Ching-Ju. YAO, Karma
English translator：CHAN, Hsiao-Lin. VERCRUYSSE, Claude
Graphic designer：LIU, Yueh-Te
Consultant：VERCRUYSSE, Claude. CHENG, Ching-Ju. YAO, Karma
Publisher：Jing Lü Art
Contact address：4F, No.3, Alley 1, Lane 269, Wu-Xing Street, Xin-Yi District, Taipei City, 110, Taiwan
Contact Telephone (Taiwan)：+886 2 27222094 / +886 922242529 / +886 926493412
Contact Telephone (Belgium)：+32 478374361
E-mail：ashui.chan@gmail.com / carolchan1975@gmail.com
Publish date：February 2016
Price: NTD 1500